CHARCOAL

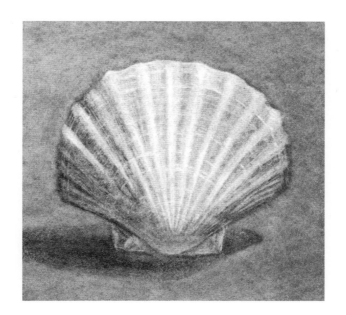

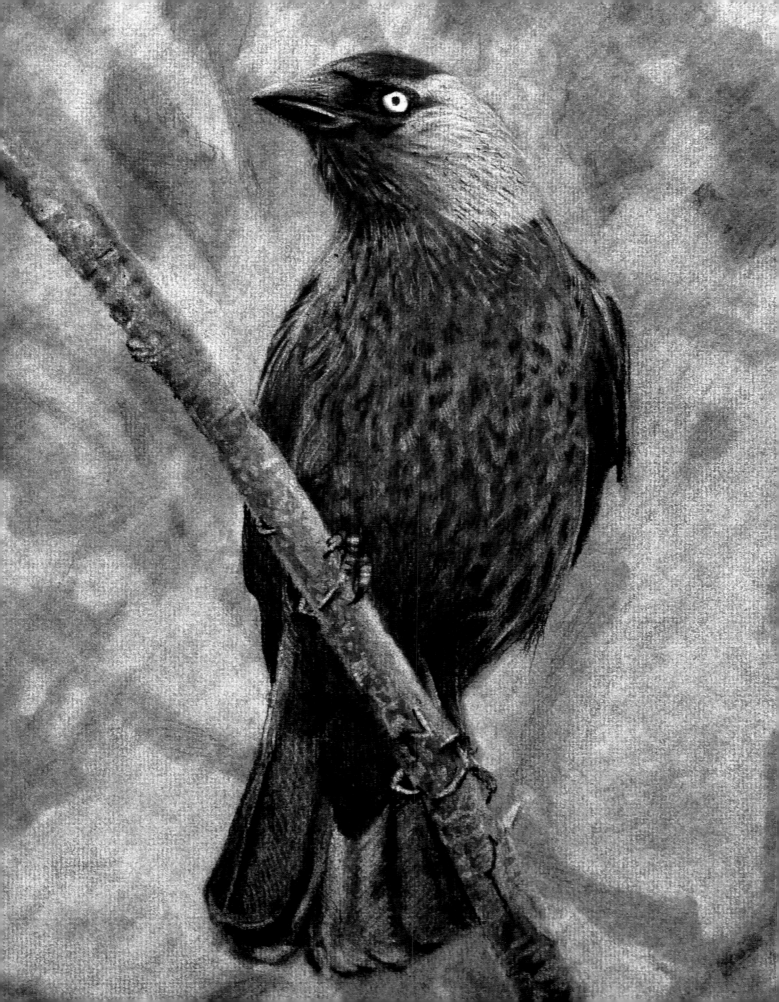

CHARCOAL

TECHNIQUES AND TUTORIALS
FOR THE COMPLETE BEGINNER

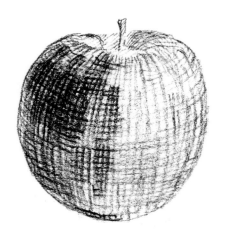

RICHARD ROCHESTER

First published 2020 by
Guild of Master Craftsman Publications Ltd
Castle Place, 166 High Street, Lewes,
East Sussex, BN7 1XU, UK

Reprinted 2022

ISBN 978 1 78494 552 7

A catalogue record for this book is available from the British Library.

PUBLISHER **Jonathan Bailey**
PRODUCTION DIRECTOR **Jim Bulley**
COMMISSIONING & SENIOR PROJECT EDITOR **Dominique Page**
EDITOR **Theresa Bebbington**
MANAGING ART EDITOR **Gilda Pacitti**
DESIGNER **Wayne Blades**
PHOTOGRAPHER **Richard Rochester**

Set in Baskerville Roman
Colour origination by GMC Reprographics
Printed and bound in China

FSC
www.fsc.org
MIX
Paper from
responsible sources
FSC® C144853

Contents

Introduction 8

Materials and Equipment 10

Lines and Shading 14

Understanding Tonal Values 16

Light and Shadow 17

Blending 18

Subtractive Drawing 19

Laying Down an Even Mid-tone 20

Observational Drawing Techniques 21

Perspective 24

Composition 26

Vegetables Still Life 28

Scallop Shell 34

Still Life with Water Jug and Plants 40

FOCUS ON *Planning Your Work* 46

Sailing Dinghies on a Still Morning 48

Landscape Sketch 54

Sailing Ship 60

FOCUS ON *Preserving Your Work* 66

Jackdaw 68

Chiaroscuro Night Scene 74

Portrait 80

FOCUS ON *Advanced Techniques* 86

Shire Horse 88

Glossary 94

About the Author 95

Acknowledgements 95

Index 96

Introduction

Humans have been using charcoal to create art for at least 30,000 years and its appeal is stronger now than it ever has been before, so what is it about the medium that makes its allure so enduring?

For me, there is something wonderfully tactile and elementally simple about a stick of charcoal. In its purest form, it is nothing more than a piece of wood with the impurities burned out of it. What remains is a beautifully dark, lightweight stick that sits comfortably in the hand. When you pick up a piece of charcoal, you feel compelled to draw with it, and this is when you can discover the rich velvety marks that it leaves – marks that can be smudged, smeared and easily erased to produce an array of different effects.

Artists love using charcoal because it is so soft that it feels like it is dissolving onto the paper. It is possible to produce thick lines and large areas of shading extremely rapidly, which encourages an expressive and carefree form of art that makes it particularly well-suited to working on a large scale. For those who prefer working on a smaller scale, and who value subtlety, it is a medium that enables very fine gradations of tone, and it can be reworked repeatedly as the image evolves or to correct mistakes.

Aesthetically, there is the captivating and somewhat glamorous charm of monochrome. There is a timeless, nostalgic quality to black-and-white images that makes them look great anywhere and explains why they never go out of fashion.

In short, charcoal is an incredibly versatile and forgiving medium, capable of producing stunning results. In this book, I aim to provide a comprehensive overview of the subject. As you work through the book, you will gain a 'virtual toolbox' of knowledge, techniques, skills and terminology that will empower you to take your own project ideas from the concept stage all the way through to a finished piece of artwork.

In the first section, I will explain the difference between the product types and teach you the techniques to get the most out of them. I have included some fundamental knowledge and skills that are common to all representational art, including the basics of observational drawing, perspective and composition. As such, this book is suitable for people entirely new to art, but it is also suited to more experienced artists wanting to gain a greater depth of understanding of charcoal as a medium.

You will find suggestions for good planning and preparation for the projects, which can save you a lot of time and disappointment later on, as well as a host of tips. You will also find information on how to preserve your finished artwork to ensure it stays looking good for years to come.

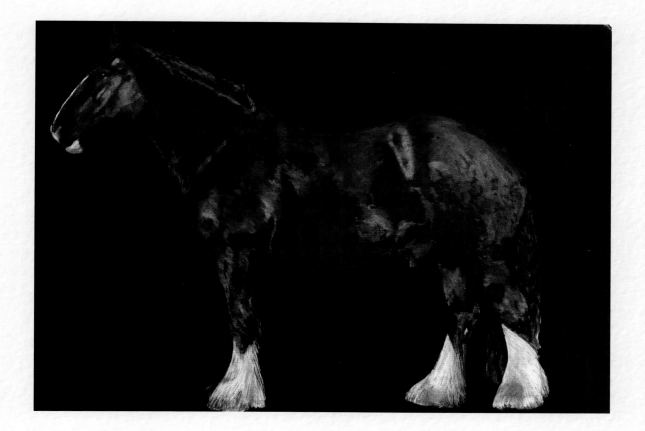

On a final but important note, you should not lose sight of the fact that the materials, tools, techniques and equipment are just one aspect of what you can use to create works of art. The most important element is you as the creative force behind the work. There is no need to slavishly mimic my style of work – that's not the aim of this book. The aim is to provide you with the foundations from which to develop your own style. The key to this is to grasp the basics through the tutorials and then to experiment; in that way, you will develop your own, unique artistic approach.

Happy drawing!

Materials and Equipment

One of the most appealing things about charcoal drawing is you need only a sheet of paper and stick of charcoal to create wonderful results. However, other equipment can help you push the boundaries of your work and make life easier for you. You can experiment with using different charcoal, paper and tools to learn what best suits you, but here are some basics to get started.

Charcoal

One of the most important things to understand is that natural charcoal and compressed charcoal are different – and there are pros and cons to both of them.

NATURAL CHARCOAL

Traditionally, artists use natural charcoal, the cheapest and most commonly available form. It is generally made from willow, grape vine or linden wood. What you can purchase locally will depend on where you live, but they all produce similar results. Throughout this book I will use 'natural charcoal' as the generic term for all three versions.

Brittle and powdery by nature, when you start drawing with natural charcoal you will find it virtually dissolving onto the surface of the paper, essentially leaving a trail of loose particles that form a matt black or dark grey mark. It is easy to move these particles from one part of your drawing to another and to blend, grade and even out tonal areas. Because it is so soft, natural charcoal requires no effort to apply and you can fill large areas of tone quickly. Another key quality is how easily it can be erased to reveal the original surface. It is a great material for expressive and atmospheric work.

However, these same qualities that make natural charcoal so appealing to work with also impose some limitations. Its soft and brittle nature means thin sections break easily and it is impossible to maintain a sharp point. This makes it difficult to draw fine detail. It is also hard to produce really dark blacks: because of its powdery nature only

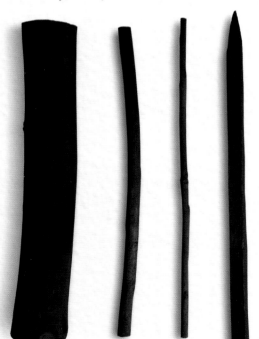

Natural charcoal is usually available in pencil-length sticks ⅛–⅜in (3–10mm) thick, but you can also buy chunky sticks at 1in (25mm) thick.

Compressed charcoal is available in pencil and block form. There can be significant differences in the quality of products, so try different brands to discover the ones you prefer.

a certain amount of the material sticks to the drawing surface, so the best you can hope for is a dark grey. These are not problems if your artwork plays to the strengths of the medium, but if you want darker tones and finer detail, you will need to use compressed charcoal.

COMPRESSED CHARCOAL

Binders such as wax, gum or a resin are added to the charcoal particles in compressed charcoal. These binders enable manufacturers to control the hardness or softness of the material as well as regulate the grey scale value (see page 16), enabling them to produce very dark blacks or a graduated range of greys. In pencil form, you can sharpen compressed charcoal to a point for fine detail. In block form, you can achieve broad sweeps of tone and lines of uniform width.

Because it is designed to adhere to the drawing surface more effectively than natural charcoal, compressed charcoal is useful if you want to get really dark tones or if you want to work in layers without losing your underdrawing. However, the flip side is that it is more difficult to erase if you make a mistake or if you want to reveal your drawing surface.

Following the same HB scale used for graphite pencils, all compressed charcoal pencils are on the B scale: a higher B number indicates progressive blackness – or softness. But some compressed charcoal pencils are graded as 'soft', 'medium' and 'hard' or 'dark', 'medium' and 'light'.

CHARCOAL POWDER

Artist's charcoal powder is natural charcoal ground to a fine powder and is used to create even tones or mixed with oil or other binders to produce a paint. You can create a similar effect with natural charcoal sticks, but powder produces more consistent results. Buy charcoal powder manufactured for the art market – it does not contain gritty particles that could damage paper.

WHITE CHARCOAL

White 'charcoal' is not really charcoal but is designed for using with charcoal to create highlights. White charcoal is handled much like compressed charcoal.

Paper

The drawing surface is the foundation of an artwork and is as important as the drawing materials. For most charcoal drawings, a good-quality drawing paper, such as heavyweight cartridge paper, is fine but there are factors to consider.

If the brightness and whiteness of the paper is important, look for 'high-white' or 'ultra-white' paper. You can also choose papers in a range of colours, earth tones and mid-tones. These tend to be marketed for use with pastels, but they are equally suitable for charcoal.

The unique properties of natural charcoal require a paper that traps the fine particles. This is known as 'tooth'. A paper with good tooth holds more charcoal, so you can build up darker tones; too little tooth and the charcoal will not stick to the paper, making it difficult to get good results. The quality of tooth is less critical when using compressed charcoal: the binding agents help the medium stick to the paper.

The texture affects the drawing: smooth paper allows for finer detail, but rough paper is great for creating grainy effects and soft edges. Art paper is sold in three categories of texture: hot pressed, cold pressed (or 'not') and rough. Hot pressed paper is the smoothest, rough paper has the most texture, and cold pressed is between the two.

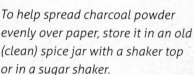

To help spread charcoal powder evenly over paper, store it in an old (clean) spice jar with a shaker top or in a sugar shaker.

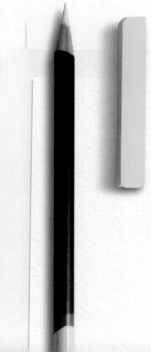

White charcoal is sold in pencil or block form.

Not all 'white' papers are equally white. When you compare them together, you can see the variations.

Other useful equipment

ERASERS

A collection of erasers of various shapes and degrees of hardness is useful not only for erasing but also for blending and smearing. However, you can achieve a great deal with just a standard block or kneaded eraser and a pencil eraser.

A hard block eraser is good for revealing the white of the paper or for cutting through compressed charcoal. A soft kneaded eraser is used with natural charcoal for fine detail, making delicate adjustments to tonal values and lifting charcoal particles from the paper. You need to work it between your fingers until it is soft and tacky, then you can shape it to suit a particular drawing task.

Pencil erasers allows for accuracy and fine detail. Those in a stick form work like a mechanical pencil but dispense a long, thin eraser. They can be more comfortable to hold than other erasers and come in a range of thicknesses.

An electric eraser rotates the eraser element at high speed, which is ideal for revealing the original surface. A less expensive but surprisingly effective option is the eraser at the top of a pencil.

BLENDING AND LIGHTENING TOOLS

You can use a paper-based blending tool to smudge and smear loose charcoal particles around the paper or to subtly remove areas of charcoal to lighten tone. A paper stump is formed from reconstituted paper fibres, whereas a tortillon is made from a single piece of paper rolled tightly. Both are inexpensive, produce similar results and come in a range of sizes. Some are pointed at both ends so you can use either end. In this book, 'blending stump' is used as a generic term for both.

A soft cloth is useful for lightening areas of tone. Traditionally, chamois leather is used, but an excellent alternative is bamboo kitchen cloth. You can also use tissue paper and kitchen paper towels.

SHARPENING TOOLS

Compressed charcoal pencils will need sharpening. Ordinary pencil sharpeners will do the job but cut away a lot of the charcoal with the wood. You can use a craft knife instead to carefully carve away the wood, leaving about ⅜in (10mm) of the compressed charcoal revealed. This will allow you to use the side of the pencil lead to cover broader areas of tone.

You can also use a sanding block to put a point on any natural charcoal or compressed charcoal, but a sheet of any medium-grit sandpaper is suitable too.

FIXATIVES

Charcoal drawings are susceptible to smudges and marks when handled or stored. Spraying a drawing with a fixative will glue loose particles to the image so they don't rub off. It also helps screen the image against damage from sunlight.

Apply a 'working' fixative as the work progresses to enable a layering of charcoal that produces darker tones, to avoid the

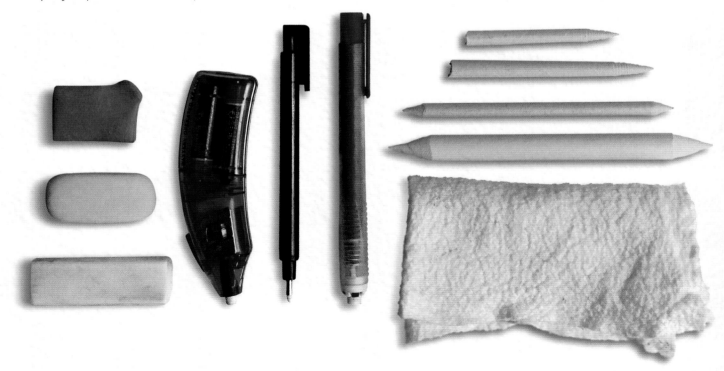

Erasers (from left to right): two block erasers and a kneaded eraser (top), an electric eraser, super-fine pencil eraser and a pencil eraser.

Blending tools (from top to bottom): two tortillons, two paper stumps and a bamboo cloth (folded into a pad).

smudging of lines as you work or to protect the work between drawing sessions. Apply a 'final' fixative at the end of the process.

Fixatives can slightly affect the tonal values of the drawing. To minimize this, you should follow the fixing process properly (see Focus On Preserving Your Work, page 66).

PAINTBRUSHES

A mixture of artist's paintbrushes (their quality doesn't matter) is useful for applying charcoal powder, softening edges and creating highlights. Have a range from short, stiff paintbrushes for brushing charcoal from the paper to long, thin, soft paintbrushes suitable for making subtle changes to tonal appearance.

MAHLSTICK

A mahlstick is useful for working in the centre part of a large drawing. It has a padded end that rests on the drawing board, and you rest the wrist of your drawing hand on the stick as you work.

It will help you to maintain fine control as well as keep your hand away from the surface of the work, preventing smudges and smears. You can purchase one in an art shop or online.

Studio equipment

You do not need to have a fully equipped art studio to make ambitious art but there are a few items that you should consider investing in if you plan to do a lot.

DRAWING BOARD

Choose a board that will not warp, is not too heavy and has a smooth surface. A good-quality piece of plyboard or MDF will do. The bigger the board, the thicker it needs to be to prevent warping. Look for a wood thickness of between ¼in (6mm) for a small board to ⅝in (15mm) for a large drawing board.

Seal the wood, especially if it is MDF, with acrylic varnish to protect its surface from water damage when cleaning off the

charcoal. You will also need clips, pins or brown paper gummed tape to secure the paper to the board.

EASEL

You may want an easel. For example, if you enjoy observational drawing, it will let you view your work and subject on the same plane and make visual comparisons more easily. It will also allow you to step back from your work to see it at a distance. What you select will depend on the size of your work, how portable the easel needs to be and if you will want to use it outdoors.

LIGHT

For still-life and portrait drawing, you will need a light that you can angle to a desired height and direction. It will give you a consistent single light source that does not change, like sunlight does, throughout the day. You can also use it to adjust the shadows in your composition. As well as lighting the subject matter, you may need to light your work area too.

Sharpening tools (from left to right): a disposable craft knife, a sanding blocking and three pencil sharpeners, one of which stores the shavings.

The end of a mahlstick is padded to protect the work.

Paintbrushes (from left to right): short, stiff brush to remove charcoal; long, soft brush to soften edges; fan brush to create foliage; watercolour wash brush to apply charcoal powder.

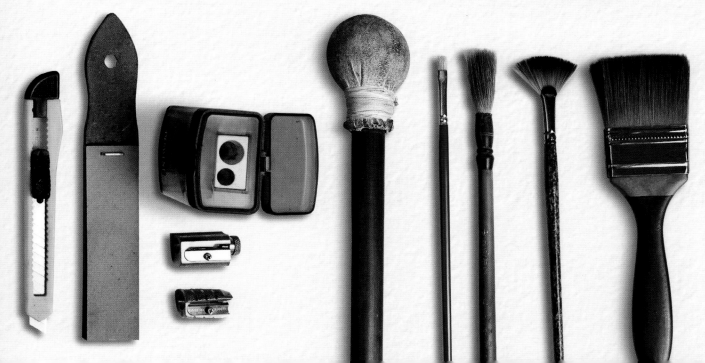

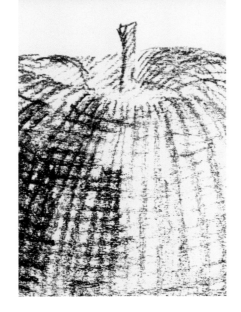

Lines and Shading

When applying charcoal to a surface, you can draw lines or areas of shading. Here is a look at these two basic methods, focusing on how to create different line widths, how to hold your charcoal and adjust the pressure you apply, and the different techniques you can use to create shading.

Line width

When drawing a line with charcoal, you should consider its width. You can achieve different thicknesses of line simply by using a thicker or thinner piece of charcoal. However, you need to be aware that very thin natural charcoal breaks extremely easily. Although you can, to some degree, sharpen the tip of natural charcoal on a sanding block, it will become blunt again quickly and it will not be possible to press hard

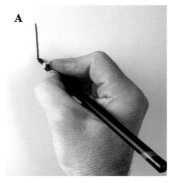

Different thicknesses of charcoal produce lines in different widths (above top). A piece of charcoal can be dragged on its side to produce a wide line or to block in large areas (above).

enough to get a dark line. Nevertheless, a really thin piece of charcoal can give you a consistent line that is less than ⅛in (3mm) wide, while a thick piece can give you a consistent line more than 1in (25mm) thick.

Likewise, with compressed charcoal, different-sized blocks produce different widths of lines, and compressed charcoal pencils can be sharpened to draw narrow lines. However, the medium is relatively soft compared to graphite pencils and will therefore require more regular sharpening to maintain their point.

Adjusting pressure

You can regulate the amount of charcoal on the paper, and therefore how light or dark it is, by adjusting the pressure as you draw. Changing the way you hold the charcoal in your hand will help you control the amount of pressure being applied. A standard pencil hold with a compressed charcoal pencil allows good control for fine detail (**A**). A firm holding position allows charcoal – whether natural or compressed – to be pressed hard into the paper for darker lines or shading (**B**). A lighter hold will produce lighter lines or areas of shading (**C**).

D

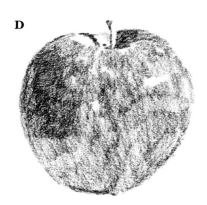

E

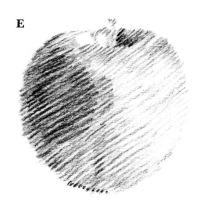

H

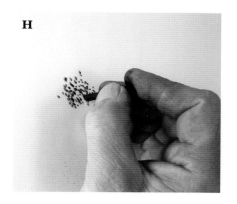

Shading

You can fill areas of paper with value (see page 16) by shading them, basically by drawing lots of lines. You can then leave the lines visible to achieve a certain finish or effect, or blend them together for a more even finish. The method you choose will depend on your personal preferences and individual drawing style.

Basic shading involves using a rapid, tight zigzag motion and regulating the pressure as you draw (**D**). You can add layers to further darken the values, such as on the left side of the apple.

HATCHING

In the same way, you can draw lots of parallel lines with white space between them. The more space between the lines, the lighter the value; the less space, the darker the value. When drawing lines going in only one direction, it is known as hatching (**E**). Adding an additional layer of lines at a 90-degree angle produces a darker value with a technique known as cross-hatching (**F**). A further development from this is the use of contoured hatching or cross-hatching to give the impression of volume (**G**).

STIPPLING

The technique of stippling requires you to hold the charcoal on its end and make marks in the manner of

F

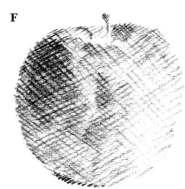

G

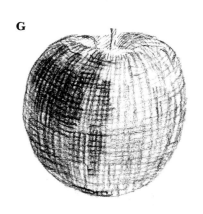

a woodpecker (**H**). As with previous methods, the value can be regulated through both the amount of pressure applied and the closeness of the marks (**I**). Some pieces of charcoal are better for stippling than others. Generally speaking, the softer the charcoal is the better, so try a few different pieces until you find one that works well for you.

The white of your paper is an important factor when regulating how light or dark your value appears. Light passes through the thin layer of

I

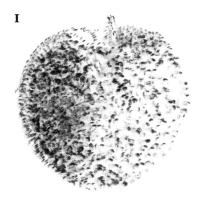

charcoal and bounces off the paper, so the more charcoal you add, the more of the white of the paper you block out and the darker your value appears.

You can also use the tiny peaks and troughs of textured paper (see page 11) to your advantage. By drawing lightly on the paper's surface, the peaks are dark and the troughs are light. When seen from a distance, the effect is like mixing black and white paint with a resultant shade of grey.

In the close-up below, you can see the charcoal is drawn on only the surface of paper. While more obvious on heavily textured papers such as this, the same applies to smoother papers.

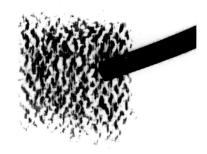

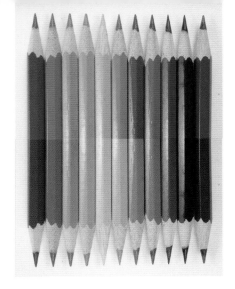

Understanding Tonal Values

The degree to which something is light or dark is referred to as its value or tonal value (or tone or shade). Values are important in monochrome mediums such as charcoal because you cannot use colour to differentiate one object or surface from another.

ABOVE *When converted to monochrome, reds and blues appear darker; yellows and greens, lighter.*

From colour to monochrome

When you look at an object, you normally sense relative areas of light, dark and colour. But when it comes to creating the illusion of three dimensions in charcoal drawings, you can transfer these areas only as dark and light onto your paper. However, colours don't translate to monochrome as you might expect, with some colours appearing darker while others look lighter (see above).

From left to right, how you see in colour, how you see in monochrome and what you could draw with six steps of value.

Values range

The difference between the lightest value and darkest value is known as the values range. When you look at things in the real world, you can discern a broad range of values – from a blinding light to an impenetrable dark. You can also distinguish subtle differences between values.

The range of values you can achieve is limited by the materials you use. You cannot go lighter than the lightness of your paper and you cannot go darker than your darkest drawing medium. This is why it is important to select your materials carefully to achieve the results you want.

LIMITED RANGE IN ART
It is difficult to accurately draw more than a few different shades of value. Most people can achieve around six distinct steps of values (plus an additional step darker with compressed charcoal)

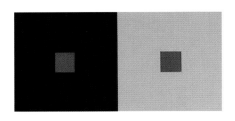

Looking at the two grey squares in the centre of the larger squares, notice how the left one looks lighter than the right – however, they are exactly the same shade of grey.

– which is fewer than you see. When you strip away the colour and reduce the number of tonal values you can draw with, the boundary of one object frequently appears to merge into another, resulting in a simplified image.

Simultaneous contrast

In a phenomenon known as simultaneous contrast, the way you perceive tonal values in an object is affected by its background. Two objects can have the same shade of grey, but one on a black background appears lighter while the other on a white background appears darker (see above). You can use this contrast to enhance the impression of light or dark in your drawings by adjusting the values in relation to one another.

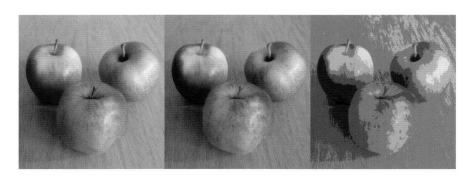

Light and Shadow

Being aware that rays of light often behave in surprising ways, and learning how to observe subtle variations of light and shadow, will help you to draw more realistically.

Observing light

Light rays travel in straight lines from light sources before bouncing off surfaces to be perceived by you as relative areas of light and dark. The colour, material and texture of an object, as well as the angle from which you see it, all have a bearing on how you see light.

As an artist, it is not necessary to understand the physics in detail, but it is helpful to understand how light behaves. I will highlight a few observations to help you know what to look for.

THE TERMINATOR

Looking at the three objects (right), you will see that half of each object is facing the light source and the other half is in shade. There is a blurred but clear line dividing these two halves, which is referred to as the terminator. Everything on the shaded side gets progressively darker the further the surface turns away from the terminator. Everything gets progressively lighter from the terminator as the surface turns to face the light source more directly. This is most obvious in the octagonal object, with its distinct edges, but the same rules apply to the sphere and the cylinder, where the transition from dark to light is gradual.

SHADOWS

Notice that the taller the object, the longer the shadows and that the edges of the shadows become more blurred the

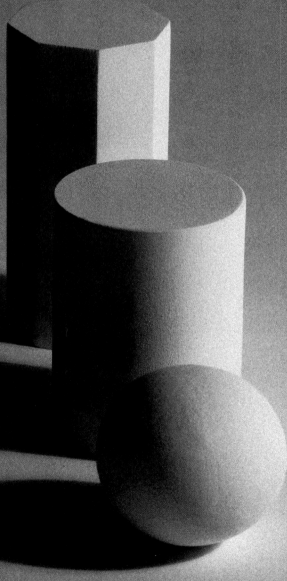

From top to bottom, an octagon, cylinder and sphere – highlighted by a light source from the right – cast shadows towards the left.

further they are away from the object. This blurred edge is referred to as a penumbra. You should also see that the shadows thrown by the objects are not a uniform value. Parts of the shadow areas are lighter or darker than others.

REFLECTIVE LIGHT

Light is reflected onto objects from the surfaces around them and from objects onto surfaces around them. Looking at the sphere, you can see that parts of the rear edge are lighter than the shadow. This is because light is being reflected onto the rear of the sphere from the surfaces around it. Likewise, light is being bounced off the sphere onto the surface beneath it to make the surface appear lighter.

SIMULTANEOUS CONTRAST

Notice the simultaneous contrast on the top faces of the cylinder and the octagon. Even though they are an even value across the surface, they appear to be lighter when seen next to an adjoining dark face and darker against an adjoining lighter face.

Blending

A technique in charcoal drawing that is perhaps just as important as the charcoal itself, blending is used extensively to manipulate the charcoal.

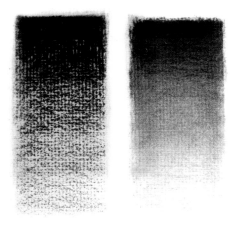

ABOVE *Compressed charcoal is more firmly bonded to the paper, so it is not as easy to manipulate as natural charcoal. Blending it into the weave of the paper achieves a dark black. You can also see how blending can soften a hard edge.*

To produce a graduated transition from dark to light, adjust the pressure of the charcoal as you apply it to the paper, then blend the values together.

Reasons for blending

When you blend charcoal, you are either working particles into the weave of the paper or lifting loose particles from the surface of the paper and depositing them elsewhere in the image. Once charcoal has been blended and effectively worked into the weave of the paper, you can repeat the process to achieve darker values. However, blending is also useful for softening edges and creating even areas of shading, and you can use it to remove hatching lines (see page 15) or underdrawing, to smooth the transition from an area of dark value to an area of lighter value, and to soften the boundaries between areas drawn in natural charcoal and those drawn with compressed charcoal.

How to blend

You can use a blending stump to blend or a soft cloth (see page 12). Blending stumps are ideal for working on more detailed areas, while a soft cloth is convenient for larger areas. To blend effectively with a blending stump, it is important to keep the side of the pointed end flat against the drawing paper so that you exert even pressure and maximize the area of the blending stump against the paper. Avoid using the sharp point unless you are trying to work into very tight corners. Papers with a good tooth produced for charcoal drawing tend to grip onto the particles, which is good for darker tonal values, but they can also be more difficult for producing even areas. Depending on the paper you use, you may need to be patient to achieve an even area of value – it may be necessary to work the charcoal into the paper from every conceivable direction.

When using compressed charcoal and natural charcoal in the same drawing, avoid contaminating areas of natural charcoal with compressed charcoal (unless you are deliberately blending them together). Either use different blending stumps or clean your stump between working on different areas.

Lightening values

If you need to lighten the values as you work, simply clean off the end of your blender with a piece of sandpaper and use the blender to lift off some of the charcoal from the paper, using the blending stump like you would a paintbrush to wipe away charcoal particles from the surface of the paper.

Hold a blending stump almost horizontal to the surface to use the flat edge of the point for blending.

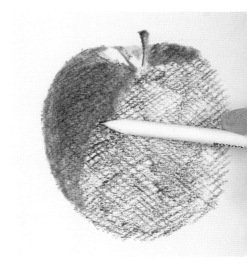

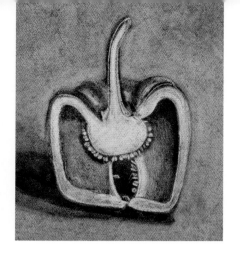

Subtractive Drawing

A technique known as subtractive drawing involves working from dark to light by removing charcoal from the paper. Instead of drawing with charcoal, you use erasers and other tools to 'draw' an image or reveal areas of lighter value.

ABOVE *By using subtractive drawing techniques, this halved pepper was drawn in reverse.*

Removing charcoal

You can use subtractive drawing if you want to create a lighter detail against a smooth and even background. You could simply draw a background around a lighter section and try to blend it in, but this is difficult to do without leaving obvious lines and marks around it. A better option is to create an even background by following the methods shown in Laying Down an Even Mid-tone (see page 20). It is important to understand that subtractive drawing is not a binary choice of charcoal or white paper. Just as with additive drawing, you can regulate the tonal value by adjusting the degree of pressure you apply. The only difference is that you are now letting light into the image rather than adding shading.

One caveat is that once applied, some of the charcoal particles will be ingrained into the weave of the paper, making it virtually impossible to get completely back to the original colour of your drawing surface. This means that if you want to keep any areas free of charcoal, you need to completely avoid drawing on them.

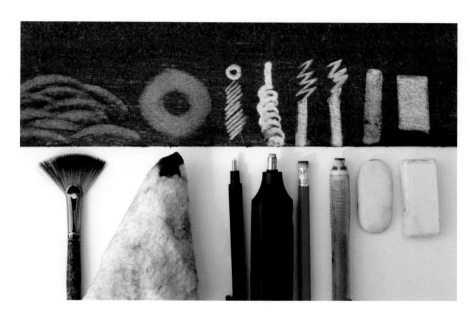

Tools for subtractive drawing include (from left to right): a fan brush, bamboo cloth, super-fine pencil eraser, electric eraser, pencil eraser, mechanical eraser, block eraser with rounded edges and square-edged block eraser.

Tools and paper

The effectiveness of this technique depends on the paper you use. Ideally, you want to use a paper with a good tooth (see page 11) so that there is plenty of charcoal to subtract from. The most common method for subtractive drawing is to use erasers, but you can also use brushes, cloths, tissues and other tools to create a variety of effects.

Tip

The eraser on a pencil is an excellent tool for subtractive drawing. You can simply draw with it holding it like a brush, and if you slice the rounded end off with a sharp knife and work it on the clean edge, you can achieve very narrow lines.

Laying Down an Even Mid-tone

For several of the tutorials in this book, you will need to begin by laying down an even mid-tone so that your entire sheet of paper is a nice even grey tone. There are two methods for achieving an even mid-tone.

ABOVE *When dragging a thin piece of charcoal to cover a large area, overlap each pass to ensure you cover all of the paper.*

Dragging charcoal

The first method involves dragging a stick of natural charcoal on its side all over the paper and then working it in with a soft cloth. The risk with this method is that any hard knots in the charcoal can scratch the paper, and these scratches will then be saturated with charcoal and show up as dark lines. This is a particular risk in drawings where you want even areas of value, such as in clear skies. One way of avoiding this is – counter-intuitively – to use thinner pieces of charcoal, which tend to be softer. Alternatively, a safer method is the second option of using charcoal powder.

Using charcoal powder

Rather than using a stick of charcoal, you can cover the paper with charcoal powder. However, it is usually a messy and dusty process so begin by making sure you are dressed appropriately. You may want to work outside and wear an apron and vinyl gloves as well as a dust mask.

Lay your paper, attached to a drawing board, flat and begin by sprinkling some charcoal powder onto the paper. Using a container with a perforated lid (see page 11) will help you to spread it more evenly. The next step is to work the charcoal into the paper. If you have a broad, wide paintbrush with soft bristles, such as a watercolour wash paintbrush, you can use it to brush it systematically into the paper from various different directions, spreading out the charcoal powder evenly across the paper (**A**). If you don't have a paintbrush, you can use a soft cloth – the results will be the same.

To use a soft cloth (see page 12), fold it into a pad and use it to work the charcoal powder into the paper (**B**). Again, try to work the powder into the paper from as many different directions as you can. Begin with a circular motion and then move to a crisscross motion. Add more charcoal powder, if necessary, to get the value as dark as possible. Your paper will largely determine just how dark this is – every paper has its own saturation point.

Finish off by very gently wiping any residual loose particles off the paper (**C**). Now move the drawing board to your workspace, but make sure you are careful to avoid accidentally rubbing the surface of the paper.

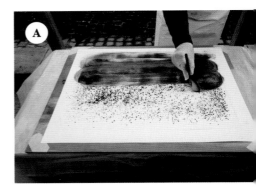

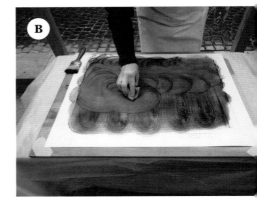

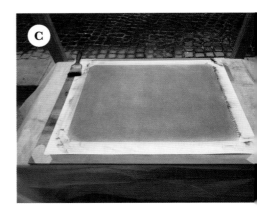

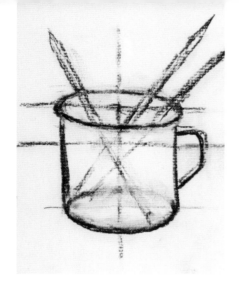

Observational Drawing Techniques

Drawing from life can be a challenging way of working but it is also incredibly rewarding. It frees you up from the constraints of working from reference material and can lead to a more expressive style.

Getting started

If you want to draw from life, it will help to understand the basic principles of observational drawing, a term referring to the process of converting what you see in front of you into a realistic drawing. Observational drawing involves a combination of sketching, sighting and measuring that is repeated as you progress through the drawing. It can be daunting for people new to the subject, but it is often easier than you might think – provided you do it systematically and follow some basic rules.

Before you start, you need to decide what you want to draw and what your composition will be. It will help greatly if you use a viewfinder, do some thumbnail sketches (see Composition, pages 26–27) or use a combination of both. Once you know which elements will be included in your picture, you can begin drawing.

Sketching

The term 'sketching' refers to the process of drawing rapidly and lightly without expecting everything to be in the right place immediately. Simply have a go at drawing it using your own judgement. Once you have the beginnings of an image emerging on paper, compare what you have

Tip
You can make your own viewfinder by cutting out a rectangle in a piece of mount board and attaching thin wire, dental floss or thread to make a grid, or purchase one from an art supply shop.

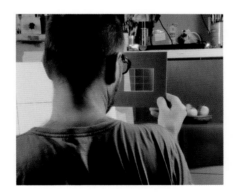

drawn to your subject matter and make adjustments until you have everything where you want it. As you become more confident that things are how you want them, firm up the lines by applying more pressure or by adding tone to define elements in the image.

Throughout this process you should use techniques known as sighting and measuring to help you get everything in the correct place.

BELOW *Sketching is a more intuitive process than measured drawing – it requires you to take a leap of faith and just start drawing. Practising often will build your confidence and skills.*

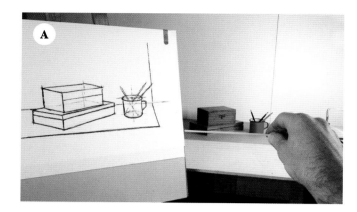

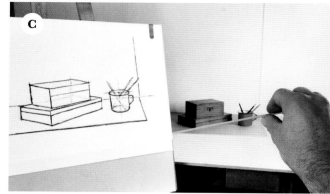

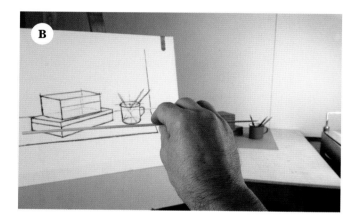

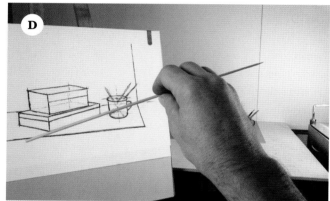

Sighting

An object with a straight edge is useful for sighting, a process in which you make vertical or horizontal comparisons of points or compare the angles in your subject matter against those in your drawing. A pencil works okay for sighting, but you may find it easier with something longer and thinner, such as a thin piece of dowel (wooden kebab skewers are perfect for this task).

HORIZONTAL SIGHTING

By holding the stick horizontally, in this example (**A**) you can see that the bottom left-hand corner of the lower wooden box is below the bottom of the cup.

By shifting the stick to the drawing (**B**), you can then check that it is correct and adjust it if necessary. Do the same to check the vertical alignment of the objects in the still life.

ANGLES AND INTERSECTIONS

You can use the same straight-edge tool to check angles and intersections. In this example, you can take a sighting along the bottom of the lower box to check that the angle of the box is correct (**C**). By holding your hand in the same position and turning around to the drawing (**D**), you can check that you have captured the angle correctly. You can also see that a line extended from the box towards the cup should intersect about halfway up the cup handle and check this at the same time.

Tip

You can use a proportional divider for measuring distances in observational drawing and when working from reference images. It allows you to accurately measure the distance between points in an object and transfer them to your drawing. You can draw on a scale of one to one or, by moving the pivot point, you can scale up or down.

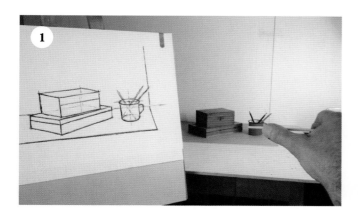

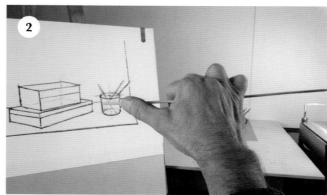

Comparative measuring

You can confirm the relative distance between points by measuring and comparing them. The simplest method is called comparative measuring and can be achieved using the same pencil or straight-edge tool you use for sighting. As the term suggests, it is a case of measuring a distance and then comparing it against other distances in your drawing. In this way, you can determine whether it is longer, shorter or about the same.

Once you have measured a distance, you might be tempted to just transfer your measurement directly to your paper. However, drawings tend to be drawn to a different scale, so many artists use the measurement to make a broad judgement.

So, for example, when measuring the width of the cup (**1**) and then comparing it to other elements in the still life, you can see that the width of the cup is almost exactly the same measurement as the height of the top box and that two times the cup's measurement is slightly longer than the side of the same box.

You can then turn to your drawing (**2**) and measure the width of the cup in your drawing. Whatever the actual measurement is, use it to make sure the other measured elements conform to the same proportions as those in the still life. In other words, as in the still life, the width of the cup in the drawing should be almost exactly the same as the height of the top box in the drawing, with the side of the box being slightly under two times the cup's measurement.

Being consistent

Repeat this sketching, sighting and measuring cycle until you have everything where you want it.

It is important to note that you must measure from exactly the same point every time, otherwise your measurements will be inaccurate. Sit or stand in the same position every time you take a measurement, and stretch your arm out to arm's length. If you try holding your arm halfway outstretched, it will be difficult to ensure that you maintain exactly the same distance from your eye each time. If sitting, it is advisable to use a chair with a back rather than a stool. This way you can press the small of your back into the chair back, forcing you to adopt the same upright position every time. To avoid the risk of your chair being moved or of you failing to stand in exactly the same place, you can mark the position of the chair legs or your feet with tape or some other marker.

Sketching, sighting and measuring, done systematically and with careful observation, can result in a surprising degree of accuracy, so don't give up too quickly if you're initially finding it a little challenging to master. Like all skills, it just needs a little practice.

Negative space

Not only should you concentrate on the objects in the drawing but also on the space between them. Sometimes you can be concentrating so hard on individual elements that you could fail to pay enough attention to how accurately they sit in relation to one another. To avoid making this mistake, it is good practice to look at the negative space between objects.

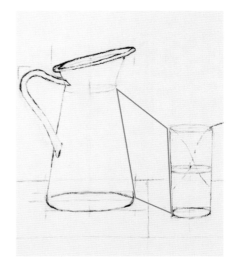

When attempting to place objects correctly in relation to one another, it helps to look at the negative space between them as shapes.

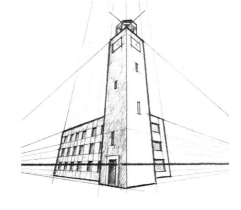

Perspective

There are two key observations in perspective – a set of rules for creating the illusion of depth in a drawing – that will help you draw things more realistically.

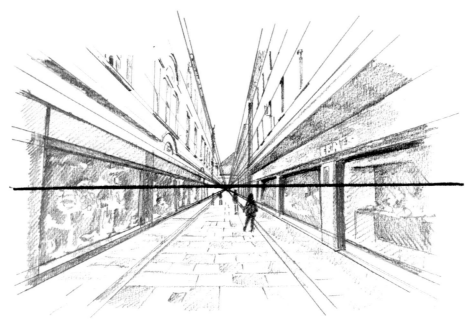

Linear perspective

The first observation is that all objects appear smaller the further away they are from the viewing point, including natural features such as clouds and waves. However, this rule is most obvious in objects with straight sides or linear features and equally spaced objects of identical size, such as telegraph poles and fence posts. This attribute is called diminution, and the method we use to take it into account is called linear perspective. This is because if you extend imaginary lines along points of equal height and alignment, they converge on the horizon line at points we call vanishing points. The horizon line is not the topographical horizon you can see but at the level of your line of sight when

A street scene shows how lines converge at a single point in one-point perspective.

The oblique angle in this building is formed by two-point perspective.

looking straight ahead. Once you work out the location of these points, you can use them to accurately place other elements in your drawings.

ONE-POINT PERSPECTIVE

Straight lines converge to meet at a single point at eye level in one-point perspective. Using a single point is appropriate when the front of objects such as buildings is directly facing the viewer or when looking down a long road, for example, or railway tracks.

TWO-POINT PERSPECTIVE

In two-point perspective, there are two points along the horizon line. This style is suitable when objects such as buildings are not flat-on but placed at an angle to the viewer. You don't need to draw physical lines to them, but use your understanding of perspective to project imaginary lines from your objects to the horizon line, and then judge whether they meet in about the right place. Be aware that vanishing points may be off the paper to the left or right of your drawing area.

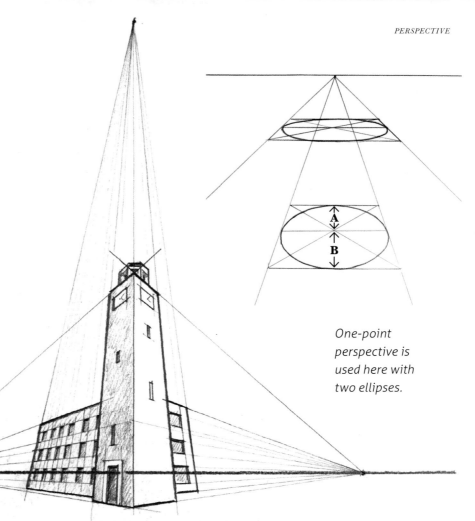

THREE-POINT PERSPECTIVE

Just as objects appear smaller in the distance, the same is true as you look up or down upon them. The most obvious example of this is when you look up at a skyscraper, but it applies to all objects. Generally speaking, it is enough just to take this knowledge into account when you sketch out shapes, but for greater accuracy you can add an additional vanishing point directly above or below your viewing position in what is termed three-point perspective.

The viewer is looking up in this three-point perspective drawing, in which the vertical lines converge towards the top.

One-point perspective is used here with two ellipses.

ELLIPSES

Ellipses feature regularly in objects in still lifes and other drawings, such as vases and bowls of fruit, so it is worth taking a few minutes to register the following two key points. The first is that the depth of an ellipse increases and becomes increasingly circular as you move away from the horizon line (see top right). The second is that line A (in the back) is always shorter than line B (in the front).

Atmospheric perspective

The second key observation on perspective is referred to as atmospheric perspective, which is also known as aerial perspective. It refers to the phenomenon that objects appear less clearly defined the further away they are from the viewing point. This is because air in the atmosphere is not completely transparent.

In atmospheric perspective, features become increasingly faint and indistinct the further they are away from the viewer.

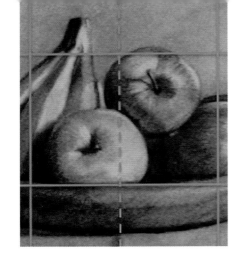

Composition

The term composition describes the way in which we place the elements within our drawings to produce the overall effect we want. In most cases, this means attempting to create something that is pleasing to the eye, but it can be used to emphasize scale or to draw attention to certain features within an image.

What is composition?

Simply type the words 'composition in art' into an Internet search engine and you will find a flood of theories, ideas and opinions. Needless to say, composition can be a contentious subject and it is largely subjective. Ultimately, you will need to use your own intuition – if it looks right to you, then it probably is right.

Even so, it is important to consider the following composition factors before you start a drawing, whether you use charcoal or another medium.

CROPPING

The first factor is something you are probably familiar with from cropping photographs on your home computer or smart phone. The principle is exactly the same in drawing: it is a case of deciding which part of the image you want to keep and which part you want to discard.

THE RULE OF THIRDS

Many artists frequently use the rule of thirds and it is recommended for being simple and effective. To apply this rule, you just need to mark out lines horizontally and vertically at points a third along the height and width of your paper (see opposite, top right). The idea is that you place key elements, such as horizon lines or the main features of your drawing, on the lines or on the points where the lines intersect. This can help you to ensure balance in your drawing and assist you in leaving enough space around your subject matter.

If you don't want to actually draw them on the paper, you can put marks outside the drawing area to show you where they are.

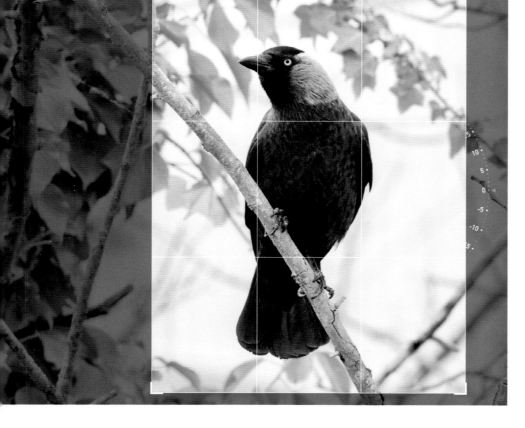

A reference image can be cropped on basic computer editing software to help decide the final shape of the drawing. Here, it is cropped from a square to a portrait format, placing the focus on the bird in the centre (within the four points of the rule of thirds grid).

LEADING LINES

Leading lines are features that draw your gaze from the front of your image towards something you want the viewer's attention to see. Typical leading lines include fence lines (see below) or train tracks, but they could be any linear feature that achieves this aim.

AREA OF FOCUS

A typical photographer's trick is to make the background out of focus so that your attention is drawn to an area in the image that is in sharp focus. This is a technique you can apply just as effectively in drawing.

CREATING DEPTH

The illusion of depth is a factor you can control in your drawings by following the rules of perspective (see page 24).

BACKGROUND

Consider carefully how your background will affect the subject matter in front of it. Emphasizing the contrast between light and dark or the simplification of a distracting background can help to draw attention to the main subject matter.

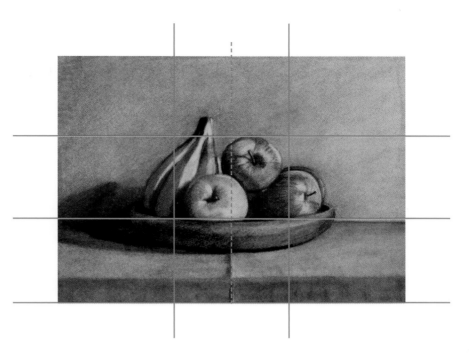

In this simple still-life image, notice how the objects are placed centrally to provide symmetry and balance while the back edge of the tablecloth is placed on the lower horizontal line of the rule of thirds grid.

The lines of the fence posts and the narrow road help to draw your focus into the image and towards the unusual cloud formation.

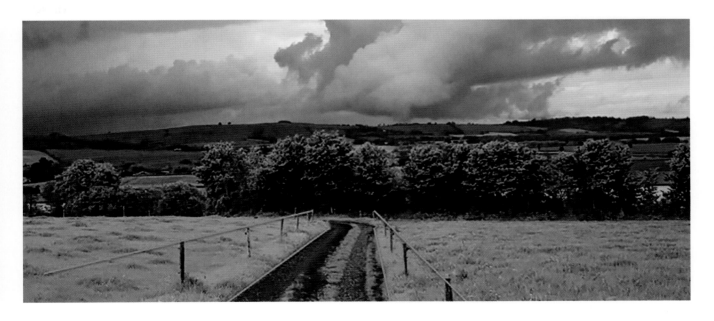

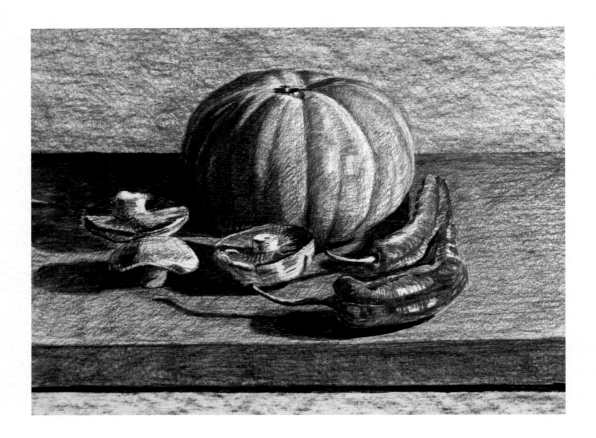

Vegetables Still Life

For our first tutorial, you will discover the drawing characteristics of natural charcoal as you draw a simple still life. You won't be using any blending techniques, so the lines of your drawing will remain visible. Vegetables offer a good range of interesting natural forms, but when starting out it's best to avoid those with overly complicated surface textures.

YOU WILL NEED

a sheet of good-quality heavyweight cartridge paper with a reasonable tooth • several thin to medium-thick natural charcoal sticks • if you have them, a viewfinder and sanding block

The still life has been a favourite genre in art for centuries. For the viewer, it provides a meditative contemplation on a scene that is often composed of ordinary and everyday objects. From the artist's perspective, it is relatively easy to set up using items from around the home and to compose it to be aesthetically pleasing.

More importantly, a still life allows the artist to set up a scene that will remain static throughout the drawing process. This means the light source can be controlled to produce highlights and shadows that will not shift, and it's ideal for practising observational drawing (see pages 21–23). Beyond this, the subject matter is only limited by the imagination, so it can be as simple or complex as you like. For these reasons, there are several still life tutorials in this book.

Although this will be a challenging exercise, it is intended to help you get a feeling for natural charcoal as a drawing material. There are two key aims: for you to practise the application of natural charcoal in a controlled manner and for you to learn to progressively build up layers of darker tonal value until you get them to where they need to be. For this reason, I would ideally like you to try and complete the exercise without using erasers. However, if you do accidentally add too much and go too dark, then simply wipe away the problem area and rework it.

Setting up

Try to place your vegetables in a pleasing way that sits nicely within your chosen format – in this case, a landscape-oriented rectangle. Think about the various composition factors (see pages 26–27) as you arrange the elements, as well as the negative space (see page 23) between them. If you have a chopping board or something else to place the objects on, you can also include it in your composition.

You should use a suitable single light source, such as an angle lamp (see page 13). Set it up to shine light from one side, slightly to the front and pointing down to throw distinct shadows. Try to take these shadows into account as you arrange the still life and make sure you think of them as part of your composition.

When composing a still life, thumbnail sketches are a great way to try out a few ideas to see what looks best. Drawn loosely and rapidly, they will help you to get into the right mindset before starting your main drawing. They will also help you to place your initial lines on the paper more confidently.

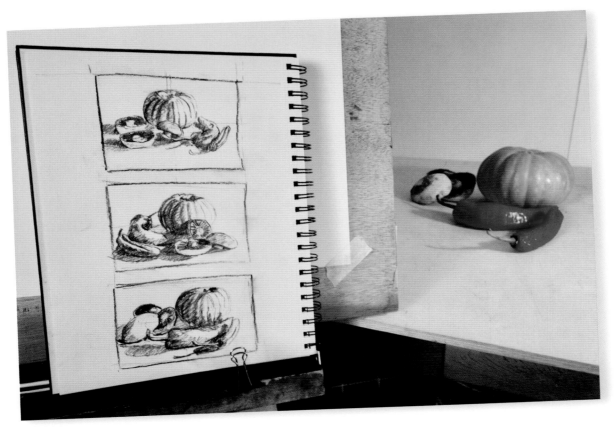

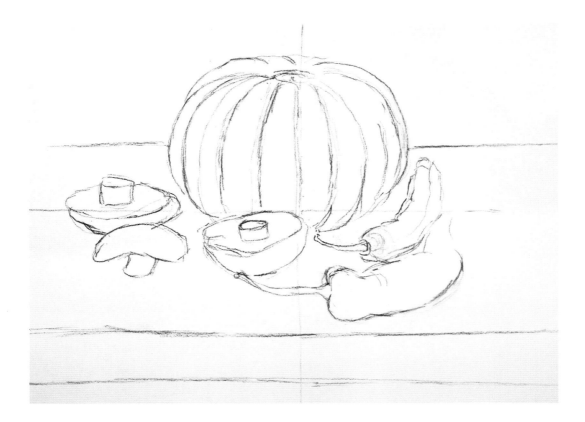

STAGE 1

To start, you should sketch out the main elements in the drawing. Take a long piece of thin charcoal – around ⅛in (3mm) diameter is ideal – and rub the edge off one end, using a sanding block or the side of your paper, to produce a slight point. Try to maintain this point throughout the sketching phase.

Lightly mark out a cross in the middle of your paper and then look carefully at your objects to decide where the centre of your composition is. You can use a viewfinder (see page 21), if you have one, to help you identify this point. In this case, the vertical centre line runs straight down the middle of the pumpkin and the bottom of the pumpkin comes down slightly below the horizontal centre line.

The pumpkin is the most prominent element of the drawing, so we will start with it. This stage is all about shape, so start by sketching in the basic outline shape quickly and loosely and, most importantly, very, very softly until you feel confident that it's about right. You can then add a little more pressure to define its final position. With the pumpkin in place, use it as your reference for everything else in terms of position and scale.

Now begin to draw in the remaining vegetables, working in order of those that are easiest to place accurately first. While doing this, continually look at the negative spaces (see page 23) between them to help you place them correctly on the paper.

When everything is where it needs to be, you can continue to define the lines a little more heavily until you have all of the main shapes in place.

Tip

If you don't have a sanding block or sanding paper, you can use a corner of your drawing paper, outside the drawing area, to hone the shape of your charcoal. You can either remove sharp edges to get a softer mark or sharpen the end to get a thinner, darker line.

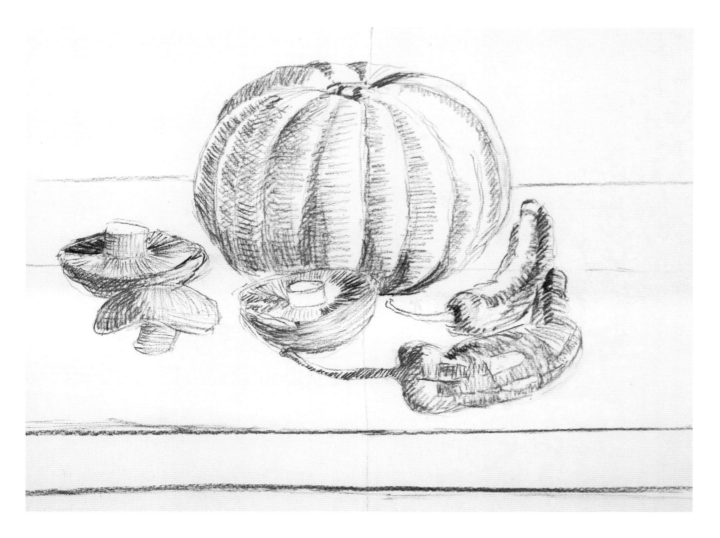

STAGE 2

Having previously focused on the shapes of the objects in relation to one another, you should now shift your observational focus to look at how the light falls on them to produce highlights and shadows, revealing their form.

Begin shading where you see it is required, using hatching and cross-hatching marks (see page 15), but be careful you don't go too dark. You are not trying to get the tonal values absolutely correct at this point – all you want to do is to map out where the light and dark areas are in relation to one another. Once everything has been given some tonal value, it will be easier to see which elements need to go darker.

Because you will not be using blending techniques in this drawing, the lines will remain visible. Try to contour the lines to reflect the form of the objects, which will really help give them a sense of volume.

You may think that the drawing looks a bit scruffy and clunky at this point, because it's difficult to control charcoal and the lines will be uneven, but stick with it. You will add layer upon layer of lines until they merge to form an evenly textured surface.

As in the previous stage, try to maintain a moderate point on your charcoal. Build the drawing up slowly and keep reminding yourself that you can always go darker but not lighter (remember that one of the challenges for this exercise is not to use erasers).

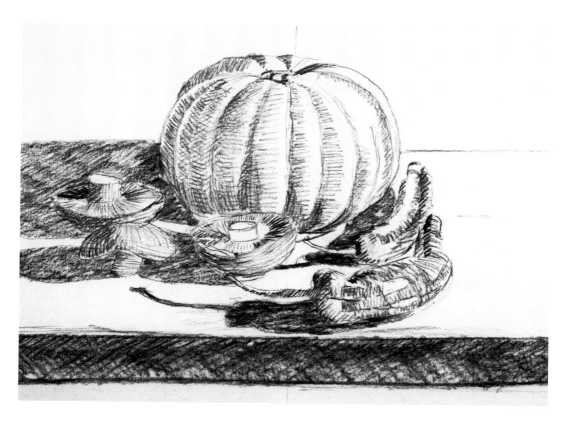

Draw a light line around areas you want to keep as highlights, as you can just see here on the side of the pepper. This will help you to avoid accidentally drawing over them.

STAGE 3

In this stage, you will be adding the shadows cast by the vegetables. As mentioned earlier, the shadows are an important element in your composition, and they also help to give the objects a sense of mass. Notice how before this stage the vegetables appeared to be floating in space, but the shadows now make it clear that they are firmly sitting on the chopping board.

When you draw out the shapes of the shadows, look carefully at the shapes in relation to everything around them, exactly as you did when drawing the actual vegetables. Remember, too, to check the negative spaces as you draw. Notice that not all areas of shadow are of equal value – some areas are distinctly darker than others.

Once you are happy that the shadow shapes are captured accurately, start hatching them in. Just as in the previous stage, avoid going too dark too early, as you want to leave yourself at least another step of value to go darker later on. Really concentrate on controlling the pressure applied to the charcoal, but allow the drawing end to become blunt so that a greater surface area of charcoal is in contact with the paper. Concentrate, too, on trying to keep your hatching lines parallel.

Hatch in the shaded front edge of the chopping board. This helps to indicate that the vegetables are sitting on a solid object. It will also provide a sense of depth by visually pulling the front edge towards you.

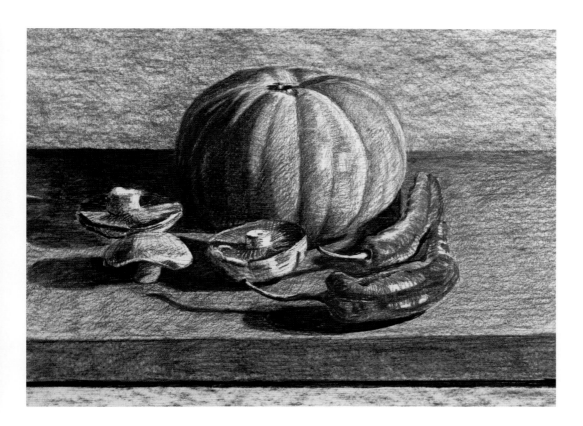

STAGE 4

Slowly, slowly build up the tone on the vegetables while continuing to follow the contours of the shapes, but avoid applying your darkest darks just yet. Keep looking really carefully to compare values across the drawing and start defining the extents of your highlights. Try to avoid drawing over the areas you identify as your highlights, because you want the white of the paper to show through in these areas.

In this case, the most obvious highlights are on the peppers. Not only is their red colour quite dark when viewed in monochrome, the surface is also shiny and reflects a lot of light.

For the flat surfaces, try to maintain parallel lines in your hatching and ensure that you apply a uniform thickness of charcoal. Draw the lines in several different directions until they produce a textured but reasonably uniform tone.

Look carefully to observe the difference in values transition between the hard edges and the more gradual transition of the rounded forms. Remember how the light fell across the three objects in Light and Shadows (see page 17) and observe how the same principles apply to the objects in the still life.

Finally, when you feel you are just about there, look carefully to identify your darkest darks and draw them in with some firm pressure. Look particularly closely at your shadow areas and identify variances in tonal value. As with the highlights, you should use your darkest values sparingly, but note how much they help in improving the illusion of three dimensions.

Build the image gradually by adding tone to all of the surfaces and constantly asking yourself if the area you are shading is lighter or darker than the area adjoining it.

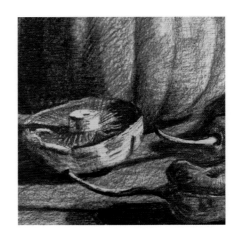

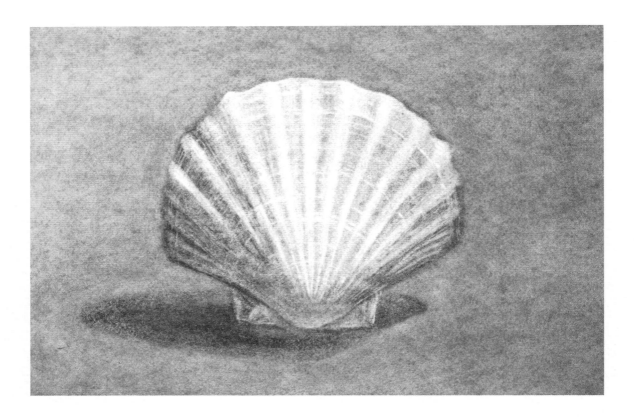

Scallop Shell

In this simple, fun tutorial, you will use subtractive drawing techniques to produce your image in reverse by starting with a dark background and working backwards using erasers. Subtractive drawing is a critical concept to grasp in charcoal drawing, and one that will add a completely new dimension to your artwork.

YOU WILL NEED

a sheet of good-quality heavyweight cartridge paper with good tooth, no smaller than 20in (50cm) along its shortest length • charcoal powder or natural charcoal sticks • a strong, soft cloth • blending stumps • a selection of erasers, including a super-fine pencil eraser

We are so used to drawing our images with dark mediums onto a light drawing surface that it can seem unnatural to think in reverse and work backwards from dark to light. The process is not as difficult as you might imagine, however, and with a little practice you will soon find yourself using subtractive drawing routinely to enhance your artwork and to create a range of interesting and desirable effects. It can also be an important process for understanding how to rescue areas if you go too dark when making a more traditional additive drawing.

The subject matter for this piece is a seashell. A scallop shell is ideal because it is a relatively simple form, but its rippled surface and convex form will cast subtle shadows that are enjoyable to try to capture.

Setting up

You will need to find something to prop the shell up against to keep it upright. Set it up relatively close to your viewing position so you can see the detail without straining your gaze. Set up a single source of light so that the light falls across the shell in a way that emphasizes the form and throws a distinct shadow of the shell but not the support.

As with the previous exercise, the learning is more important than the final piece, so you don't need to use an expensive paper. However, a paper with good tooth and some texture will help you to produce better results.

Tip
If you prefer to wear protective gloves, use vinyl gloves rather than latex ones – latex is a stickier material that tends to lift material away from the paper.

Preparing your paper

This job will produce some charcoal dust so it is best done outside. Using either charcoal powder or natural charcoal sticks, entirely cover your paper with charcoal, following the instructions in Laying Down an Even Mid-tone (see page 20). If you are using sticks of charcoal, you may find it is sufficient to simply shake off the loose particles at this point, but if you are using charcoal powder, you will need to work the charcoal into the fibres of the paper with your fingers, using small circular motions and increasing the size of the circles (you can wear vinyl gloves to keep your hands clean).

Your aim is to achieve as uniform a dark tone as you are able to, but don't worry if it is not perfect because you will be removing much of it. How dark your paper ends up will depend on the paper itself, so don't be surprised or put off if all you can achieve is a fairly light grey. Just work with what you've got – you will still learn a great deal from the exercise.

When setting up the shell, try adjusting the lighting in several different angles before choosing the one that creates the most contrast in the ridges of the shell.

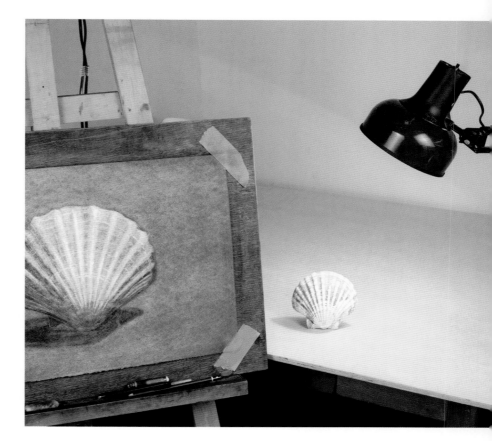

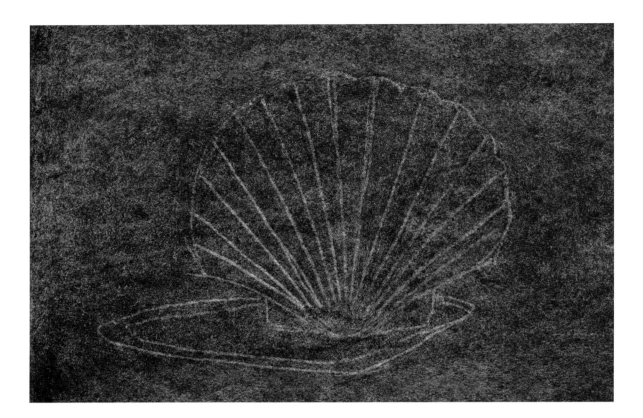

STAGE 1

Start by drawing a cross through the centre of your paper using a blending stump. It will only produce very faint lines, but that's exactly what you want – they should just be discernible to you. Now look carefully at the seashell and judge where the centre of your composition will be, making sure you include the shadow area. Having this centre lodged in your mind will help you to place the shell on your paper more accurately.

Now start sketching, again with the blending stump. Begin by trying to estimate the overall shape of the shell, and once you feel you have it broadly correct, start to work out the placement of the ridges, fanning out from the point at the base of the shell.

The drawing doesn't need to be too accurate at this stage, but try to use the full extent of the paper to draw the shell to a much larger scale than it is in real life. This will allow you to use a full range of tools and focus on details within the shell.

Work out where the fan-shaped ridges will be and sketch them in. This is tricky and will probably take a few attempts, but as you are merely making light marks, you can estimate their position for drawing them in, and then adjust them once it becomes clear that they are in the correct place. If necessary, use a narrow eraser to draw in the final position of your lines. Notice how the position of the darkest shadow has been differentiated from the penumbra (see page 17), the lighter area around the edge of a shadow.

Tip

One of the benefits of working with subtractive drawing is that it is easy to correct a mistake. Using the same natural charcoal you used to prepare the background – either stick or powder – simply apply it back over the area where you made the mistake and blend it into the surrounding charcoal with a blending stump or your fingers. Just be careful that you don't go into a finished area.

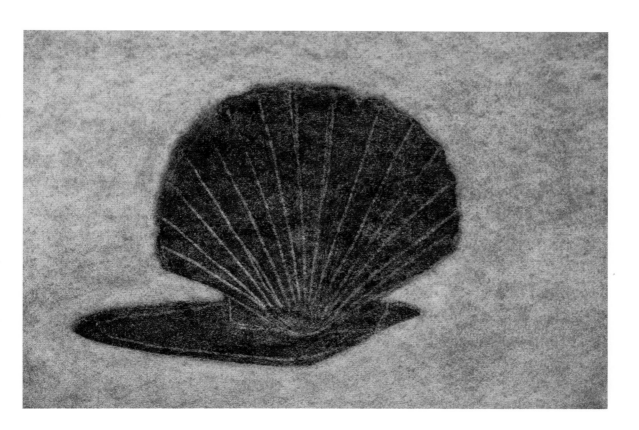

STAGE 2

Don't be tempted to use an eraser at this stage, because you need to avoid removing too much charcoal – you want to leave yourself plenty of room to go lighter.

This stage requires an absorbent and strong soft cloth to remove charcoal from the area around the shell and its shadow. Note that you will not be able to remove all of the charcoal from the paper because it is ingrained in the microscopic fibres. This means you will end up with a light grey. Just how light your grey will be depends on the paper you use. Don't worry about whether or not it is a realistic reflection of the tonal value – just keep wiping until you have lightened the paper as much as possible and removed any marks.

When using the cloth, you can shape it into a pad to wipe away the larger areas. You can also wrap the cloth around your finger or a pencil eraser to get into the corners and to try to maintain as sharp a distinction as possible between the light and dark areas. You will need to keep changing to a clean piece of cloth, because as the cloth becomes saturated with charcoal, it will merely move particles around rather than lift them out.

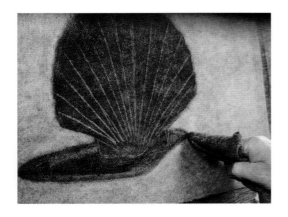

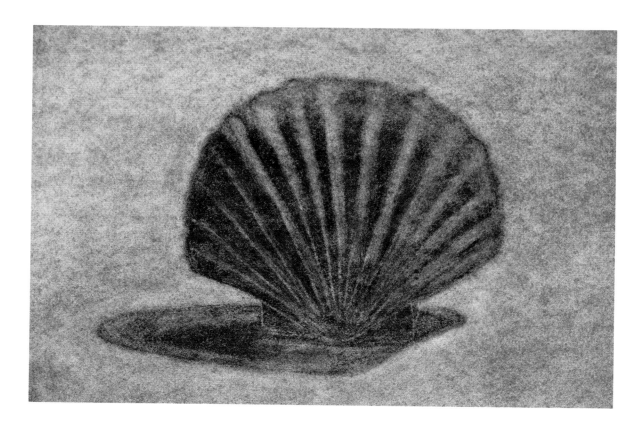

Tip

Vigorously shaking your cloth out to remove a build-up of impregnated charcoal every now and again will help keep it absorbent. If you are using a tissue, keep changing to a clean area on the paper to work with and make sure you switch to new ones if needed.

STAGE 3

Continue to use only the cloth to remove charcoal from the lighter areas of the shell and its shadow. This is the point at which you need to flip your way of thinking and recognize that instead of looking at graduations of dark, you are looking for graduations of light. You are literally letting light into the piece and, just like in 'positive' drawing in which you are adding shades, you need to do it very gradually. In this exercise, the challenge is to achieve your aim without adding more charcoal.

The key to making the shell look realistic is to keep thinking back to the spherical form in Light and Shadow (see page 17). Look at the shell as a whole form and don't immediately get drawn into the individual details without seeing them in relation to everything else around them. Where the light hits the shell most directly will be lightest. The areas that are shaded by the shell – here, the left-hand side of the shell as well as the bottom half of the shell – will be relatively darker.

You should now try to be aware of extremely subtle changes in tonal value as you work. Notice the slight differences in areas of shadow and try to emulate them in your drawing.

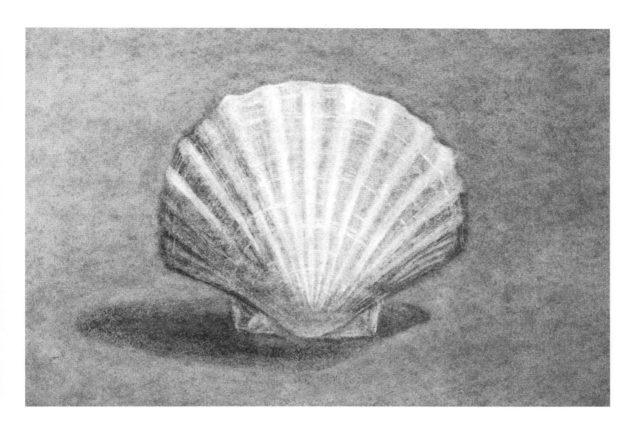

STAGE 4

Once the overall form of the shell is starting to emerge, you can begin to use erasers to further lighten the areas of value. Begin by using a rounded eraser that is not too small, and use a motion that is more of a gentle wipe than a vigorous rub. At first, you want the eraser to take charcoal off the very top surface of the paper. As you become more certain about the relative tonal values, you can very gradually press harder in the areas you want to be lighter.

This stage is a fine balancing act: you want to get progressively lighter, but you also want to save a level of value for the lightest highlights. In this image, these are the concentric growth lines on the shell. When you get to these, it helps to use a very narrow eraser that you can work hard into the paper. To achieve something close to the original white of the paper, you will need to work the eraser into the paper from various different angles. Make sure you keep cleaning it on a piece of cloth to remove any build-up of charcoal. For the finest lines, slice the very end off the eraser and hold it at an angle so you are rubbing with the fine edge.

Notice how light has been reflected off the flat surface of the table to slightly illuminate the base of the shell, even though it is shaded from direct light.

It is difficult to get completely back to the original white surface once charcoal has been worked into it, so expect the values range to be relatively narrow, from a dark grey to a light grey. This won't matter in this exercise and, in any case, it lends itself to the simple aesthetic of the drawing.

Once you feel you are almost there, take a comprehensive look at the drawing and assess all of its aspects; then do any final balancing of value or sharpening up.

As you reflect on your work, one point to consider is that it would have been more difficult to achieve the same nice uniform grey background if you had been working from light to dark. It would have meant drawing around the shape of the shell and resulted in lines and marks in the background. However, because you worked negatively, the area surrounding the shell is clean.

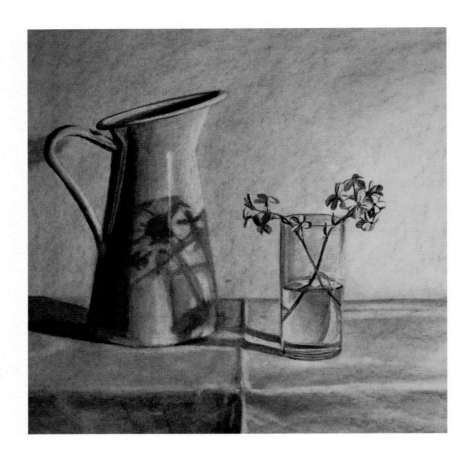

Still Life with Water Jug and Plants

Here is a tutorial aimed at adding blending and measuring to your range of skills, helping you to produce a more sophisticated still-life drawing.

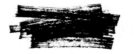

YOU WILL NEED

a sheet of good-quality heavyweight cartridge paper or charcoal paper
• several natural charcoal sticks in different thicknesses • blending stumps
• a soft cloth • erasers – a kneaded eraser will probably suffice but a super-fine
pencil eraser will be useful in the latter stages

The first two tutorials focused on the importance of having precise control of your charcoal and erasers as well as a gradual approach to get to the tonal value you want. This tutorial will introduce you to working both positively and negatively as well as how to use blending as a method of graduating transitions from lighter to darker areas of value. You will be removing the hatching lines in your shaded areas to enhance the impression of realism.

You will also be tackling a couple of ellipses and practising comparative measuring to ensure that everything is in the correct place before you start shading.

Setting up your still life

When you select items for this still life, choose two or three elliptical objects. A couple of flowers in a glass or vase will add some additional challenge and interest, but you could use a plant in a flowerpot if you prefer. Because bright colours can be distracting when you are trying to make monochrome value judgements, try to include objects that have a neutral colour. The tablecloth provides another element of interest – note how the light fall across its surface, creating shadows and highlights in the folds of the material.

For this set-up, you should use two lights: one to provide a single light source to illuminate the still life and another attached to the easel to illuminate the drawing. When positioning the light over the drawing, make sure you angle it carefully to avoid throwing a secondary light source across the still life.

When composing your still life, try to keep it simple. Have a few different objects to hand and try them out to see what works best. In this scene, the rule of thirds (see page 26) was used as a compositional guide. The back of the tablecloth, for example, lies on a horizontal line about one third up from the bottom of the picture. The jug and the glass of flowers are placed on either side of the crease in the tablecloth, which lies centrally to provide some balance. If you choose to draw flowers, try to select ones that are not too complex.

Now that you have set up your still life, take some time to just sit and observe it for a while. Notice where the light and shadow form soft or hard edges and squint to determine where your lightest and darkest areas of value lie.

Tip
There are some pros and cons to what you use for securing your paper to a drawing board. Pins leave holes behind that can show through when you later draw over them. Clips are great if you have a drawing board that is matched in size to your paper because they are clean, easy and reusable without damaging the paper – however, you can't lay the board flat. Tape is fine for most work as long as you remember to keep the tape out of your drawing area and use a suitably low-tack tape.

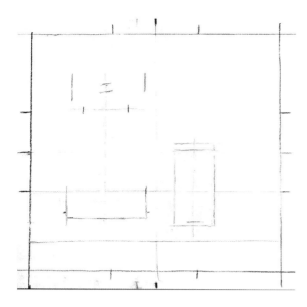

STAGE 1

Begin by marking out the extent of your drawing area. Mark out the centre lines and the position of the rule of thirds lines just outside the drawing area to help you place things compositionally. Using a viewfinder will help you to decide on a format: a square format works well with this piece, so it is marked out within the rectangular piece of paper.

With a thin piece of charcoal and pressing lightly, use observational drawing techniques (see pages 21–23) to compare and measure elements in your composition, such as identifying the left and right as well as lower and higher extents of key points in your objects. Check your measurements and angles from different points and adjust them as necessary to gradually increase the accuracy. As you become confident that the marks are correct, mark them in more clearly.

It is worth investing some time into this stage, because the further you get into the drawing, the harder it will be to rectify mistakes. You can substitute the carpenters' mantra of 'measure twice, cut once' with 'measure twice, draw once'!

STAGE 2

With the key points marked out accurately, you can tackle the ellipses and complex shape of the jug handle.

You can't see the full ellipse at the base of the jug, but draw it in roughly to estimate where the rear portion of the ellipse lies. Doing so will help you to draw the front portion correctly. Remember that due to perspective (see page 24) the front half of an ellipse will always have a more pronounced curve than the rear. The glass, although close to you, also follows the rules of perspective in that the ellipse becomes more pronounced (more oval) the further it is below your horizon line (which is above the glass). It conforms to the rules of three-point perspective, too: because you are looking down on the glass, the lines converge slightly towards the base of the glass.

Turning your attention to where the jug handle joins the jug, measure from the base of the jug to the bottom of the handle. From this point, measure the width of the handle and mark it on the paper. Do the same for the upper part of the handle, where it joins the jug. Now measure and mark where the left and upper extents of the handle lie to form a corner where the handle curves. Sketch in the shape of the handle and adjust it, if necessary. (The handle here was drawn too low and had to be erased and adjusted accordingly.)

Draw in the upper part of the jug, treating it like any other ellipse.

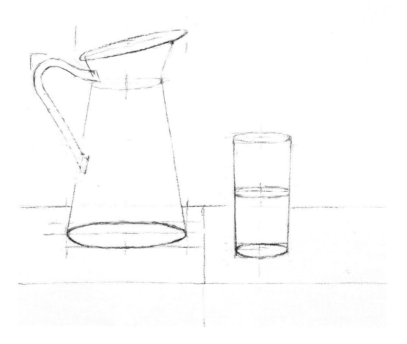

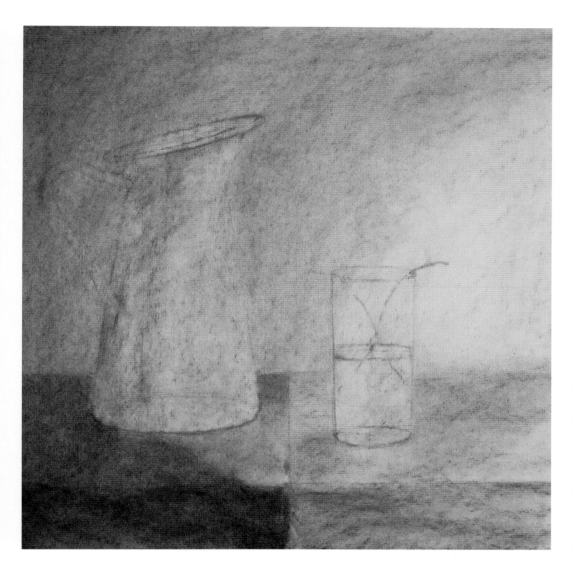

Tip
When looking closely at the still life, you may pick out areas where adjoining values are the same. For example, look closely at the right-hand edge of the jug, and you will see it is very close to the background value. In such cases, you can simply draw your charcoal straight over the boundary between the two.

STAGE 3

In this stage, you should be ready to block in the main areas of shading – without focusing on the detail. Although there's an indication of the flower stalks, for example, the flower heads have not been added. Start by looking very carefully to identify where the main areas of values are, and how light or dark they are relative to the adjoining areas.

Close one eye and squint the other to help identify how light falls across the whole area of the composition rather than just individual parts of it. You should see how the light is significantly brighter where it is closest to the light source and that it becomes significantly darker on the left-hand side of the drawing, where the light drops off.

Apply a layer of natural charcoal by hatching in or dragging, and then use a blending stump to work the charcoal into the paper. Repeat, applying layers of charcoal and working them in with a blending stump to build up dark areas. Remember that it is a case of building up the layers gradually. When you use the blending stump, work it from various different angles. This stage can be hard work and it may take some time to blend out the hatching marks, but persevere until you get it to where you want it. If you go too far and add too much, you can lighten those areas with a soft cloth or an eraser.

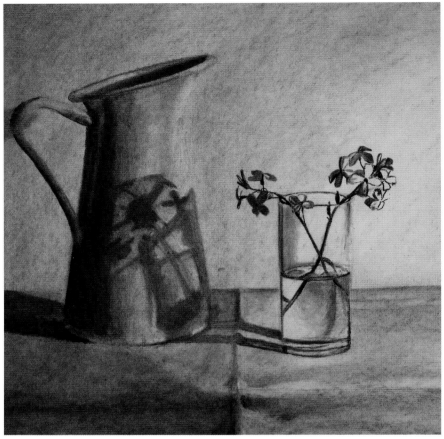

When drawing the flowers, after first getting the stalks drawn in correctly, identify the centre points of each flower head before attempting the petals. You may not need anything more than simple suggestions of light and shadow to give shape to the petals on your own flowers.

STAGE 4

With your main areas of value blocked in, you can now start defining the forms of the objects and adding detail. Begin with the jug. As mentioned in the last stage, the right-hand edge of the jug is very close in value to the background but the form turns away from the light source to become relatively darker on its left-hand edge. Notice the line of the penumbra (see page 17), where the value is significantly darker to the left and lighter to the right, and the graduated transition that tells us that the jug has a curved form. However, the shadow is darkest inside the jug on the right-hand side, where it is most shielded from the light source, and it becomes lighter on the left-hand side. Add charcoal and blend it in with a motion following the contours of the jug. Spend some time getting this right before you tackle the shadows of the flowers.

When working on the transparent glass and the water, try to imagine this area as a two-dimensional pattern of light and dark rather than a complex three-dimensional object – try really hard to just draw what you see. For the flowers, you will need to use a thin piece of charcoal and keep it honed to a relatively sharp point. Start with the stalks to get the positioning of the flower heads correct and then draw in the petals.

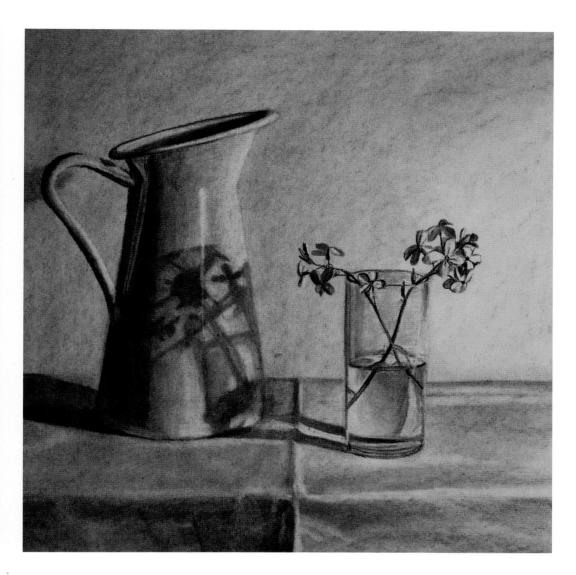

STAGE 5

Having held off the temptation to use erasers to lighten areas of value up until now, the next step is to switch mindset and work subtractively to add highlights. The key areas in this drawing are along the right-hand edge of the jug, which is very slightly lighter than the background, so very gently remove charcoal from the top surface of the paper along that edge. There is also a strong highlight on the surface of the jug facing the viewing position. The jug is metal painted white, and the highlight is correspondingly quite clearly defined. Likewise, with the jug handle and the rim of the jug mouth and the area on the left-hand side of the jug, where the light bouncing off the handle is reflected onto the shadow side of the jug.

A soft cloth is a good tool for lightening areas of the tablecloth, such as the front edge and the creases. Finally, use a very narrow eraser to lighten the petals facing the light source. Now tweak anything else required to complete the drawing.

Tip

When you think you've finished, avoid the temptation to fix the drawing and disassemble the still life immediately. It is good practice to leave a drawing in position for a while – ideally overnight – so that you can look at it with fresh eyes after you've had a break. You will often notice small errors, omissions or areas for improvement that you simply missed when you were engrossed in the drawing process.

FOCUS ON
Planning Your Work

There are a number of things to consider before putting charcoal to paper. Taking a few moments to think through your project before you start drawing can save you a lot of time and effort at a later stage. It can also help you to avoid making expensive mistakes.

Subject matter

If you haven't already decided, the first thing you will want to do is to choose a subject matter. As well as considering what is aesthetically pleasing to you, it is important to choose a subject that suits drawing with charcoal – both the strengths and limitations of the medium. Generally speaking, simplicity is the key. If in doubt, try viewing the image on a small scale. If it doesn't work well as a thumbnail image, it is unlikely to translate well on a larger scale.

If you are working from life or a coloured reference image, consider how it will look in monochrome (see pages 16). Some images are enhanced when you strip away the colour, but others lose definition and fail to work effectively. To judge tonal values, it helps to close one eye and look at the object while squinting with the other. Another useful trick is to take a quick snapshot on a digital camera or smartphone, then use a black and white filter to quickly check to see where the main areas of light and dark value lie.

Using reference materials

Reference material such as photographs, film stills and existing artwork can be an excellent starting point when planning a new artwork. The ubiquitous nature of modern media, such as smartphone cameras, means that it is relatively easy to capture imagery that can be used to create great art. The important thing to remember is that you don't need to copy your reference material slavishly. You have full editorial control, and you can choose which elements to include and which to leave out. You can alter the contrast or blur out areas to draw focus to certain areas.

Once you choose an image, you can trace directly from a print (see page 61) or scale the image to the size you want by using a grid system (see page 89), proportional dividers (see page 22) or

In this image, the tonal values range was reduced to shades of grey and the vegetation was suggested rather than drawn in detail to increase the sense of simplicity and harmony.

An image split over three standard-sized frames is a cost-effective way of producing impactful work on a larger scale. This one of the ceiling of Exeter Cathedral is around 10ft (3m) wide.

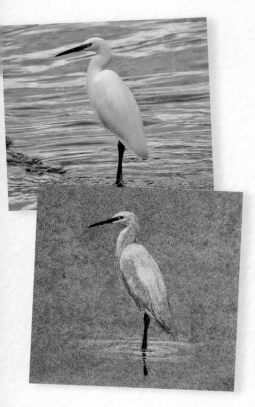

The waves in this reference image of an egret were too busy and detracted from the form of the bird, so the composition was simplified and a heavily grained paper was chosen, which gives the water and background a misty atmosphere and tranquil quality.

by tracing from a projection. It is then relatively easy to add detail and tone to produce a finished drawing.

Choice of paper

Give some thought to the type of paper your image will best work on. Heavily textured papers can greatly enhance certain types of image such as a misty scene, but if you want crisp lines and fine detail, you need a smoother paper.

If you want your work to last for years to come, also consider the archival quality of the paper. Poor-quality paper is made with an inferior size (glue) that can turn yellow or become brittle over time. Look for paper described as pH neutral or acid-free for the best results.

Format

The format of your drawing is an important consideration. Your basic options will be to produce work that is square, rectangular in a landscape format (with the width greater than the height) or rectangular in a portrait format (with the height greater than the width). Other options exist but can be complicated and expensive if you deviate from these standard frame conventions. You could display work within a circular or oval mount board within a standard frame, and you can split work over multiple panels.

Your choice will be determined by the dynamics of the image you plan to draw, but you may want to produce the work to fit a standard frame size, in which case you need to plan accordingly at this stage, remembering to take into account the width of any mount board (see pages 66–67). If in doubt, it can help to try out some different options, using a viewfinder (see page 21) for live subjects or photographs – or a crop function for digital images.

Mounts are an important element when framing drawings and can enhance their presentation, so ensure you take them into account when planning the size of your work.

Sailing Dinghies on a Still Morning

Natural charcoal is a wonderfully subtle medium.
In this tutorial, you will exploit this quality to produce a calming
and tranquil estuary scene.

YOU WILL NEED

a sheet of good-quality heavyweight cartridge paper with a good tooth
(to hold the charcoal powder) • charcoal powder • medium-thick natural charcoal sticks
• a selection of erasers • a selection of paintbrushes, soft and hard • a soft cloth
• blending stumps • sanding block

This drawing is all about subtlety and simplicity. The source material is a poor-quality photo taken on an early digital camera. On the morning the image was taken, the wind had dropped off and the water was flat, which resulted in some wonderful reflections. I snapped a few shots from a good distance away, but I forgot about them for many years. When I stumbled upon them again recently, it occurred to me that the lack of detail in the photo really enhanced the calming quality of the scene and that the image would lend itself particularly well to a drawing in charcoal.

I decided to work on a fairly large scale that would further emphasize the simplicity of the work and chose a heavily textured watercolour paper that would provide some surface texture and a lovely grainy quality reminiscent of old black-and-white photos.

To further enhance the simple nature of the drawing, I decided to use a narrow but dynamic range of values without any strong darks or light elements and to use only natural charcoal with the highlights purely where white paper is revealed through subtractive drawing (see page 19).

Choosing the composition

I cropped the image to a panoramic format, which is twice as wide as it is tall. This was to reduce the large areas of water and sky as well as to draw the viewer's attention to the central section of the image. I followed the rule of thirds (see page 26) to place the waterline on the lower line and the two visual elements of the dinghies and the dip in the landscape on the intersections with the vertical lines.

Artistic license

Although there is a lack of detail in the photo that makes it a good source for charcoal drawing, it doesn't mean that it's necessary to duplicate it exactly. Think about not only what isn't necessary but also what might enhance it. For my artwork, I used some artistic license to remove a few mooring buoys that I felt were a little distracting. There is a large expanse of still water in the foreground, where I decided to add some ripples to help create the illusion of depth.

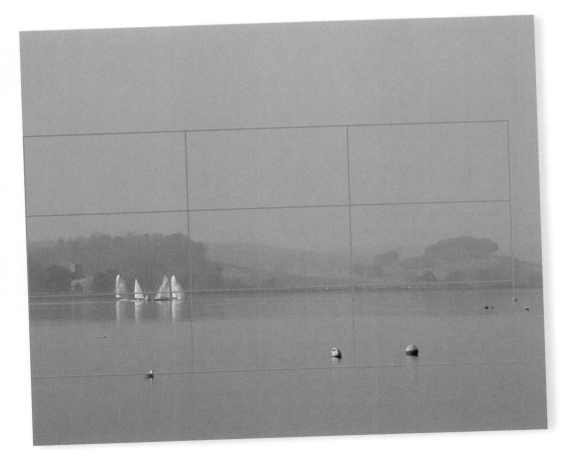

A grid divided according to the rule of thirds shows how the image was cropped to a panoramic format to reduce the areas of sea and sky and draw focus to the centre.

Tip
If you are using your own photography as a source, it doesn't matter if you choose to use a printed copy or work from the digital image – use whichever one you feel more comfortable with.

STAGE 1

Before you start drawing, you will need to prepare the paper with a layer of charcoal powder following the steps in Laying Down an Even Mid-tone (see page 20). You need to achieve a nice dark value so that you can lighten it easily using only a clean piece of soft cloth. Remember: you are working with charcoal powder, so make sure you are working on a paper with really good tooth.

If you are struggling to get a dark enough value with charcoal powder alone, then feel free to add value by using the drag method, holding a stick of charcoal so that its side is dragged across the paper (see page 20), and work the charcoal into the paper using a soft cloth or a blending stump. However, the

risk with this approach is that any tiny knots in your charcoal can scratch your paper, and these scratches will appear as thin dark lines as you work on your drawing, so only use this method as a last resort and test your piece of charcoal out before you commit it to the drawing.

Once you have the even value as you want it, use a relatively clean portion of your soft cloth to gently rub away some of the value from the upper portion of the image, above the waterline, so that the sky section is ever so slightly lighter than the water. This is because reflected sky is never quite as dark as the sky itself.

STAGE 2

Once the sky is lighter, you can mark out the composition lightly by eye with a thin stick of natural charcoal. Start with the waterline and then place the boats on the rule of thirds line intersection followed by the dip in the landscape. From here, it is relatively easy to work out the position of the remaining elements.

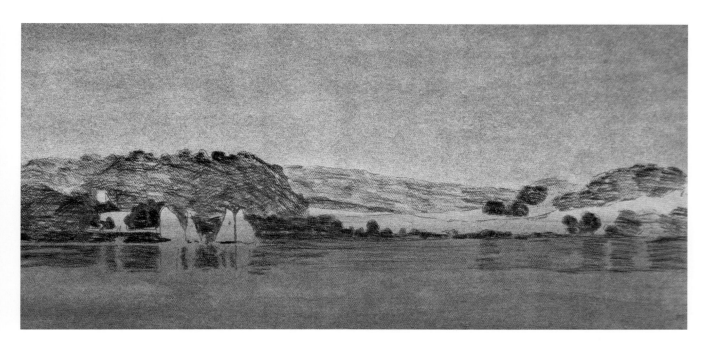

STAGE 3

With the main composition marked out and a copy of the source image to hand, start blocking in the main areas of value. Notice that the value of the field towards the right-hand side of the image is close in value to the sea and sky, so don't add any here. Work from the background to the foreground with a fairly thick piece of charcoal. If necessary, first flatten the end of the charcoal slightly on a sanding block or on a corner of the drawing paper outside the drawing area.

For the lightest tones, remember to use a long piece of charcoal and hold it near the end to keep pressure to a minimum (see page 14). Gently rub the charcoal over the paper. Don't worry if the charcoal sits on the surface bumps of the textured paper without going into all of the indentations, because the next stage is to work the charcoal into the paper with a blending stump. Don't worry too much either about getting the values absolutely correct. At this stage, your main objective is to get a first layer of charcoal onto the paper. Don't forget to add value in the reflections in the water.

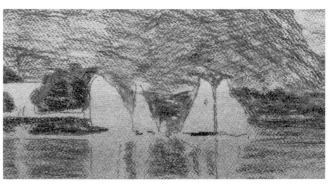

Look carefully to identify areas where the values are lighter than the mid-tone background and leave them as they are. You will lift these out with erasers later on to make them lighter.

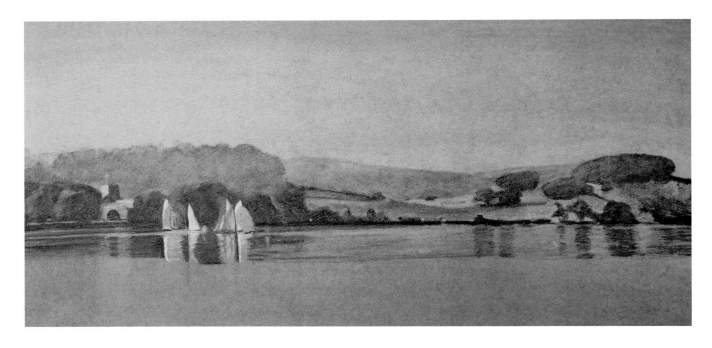

Tip
The sanding block you use for sharpening your charcoal is also ideal for cleaning your blending stumps. Just make sure you use a clean piece.

STAGE 4

Using a blending stump, begin to work the charcoal you added in the last stage into the paper. Add more charcoal and repeat the process to build up the value where needed gradually. Be aware that what you've just drawn will lighten as you blend it, so you can go a little darker than the value you want to ultimately achieve. You should make the areas of woodland slightly darker than you ultimately want them to be, because the process of adding texture and the suggestion of foliage with cloths, blending stumps and brushes will lighten the tonal value.

As you build up the layers, step back from time to time and look at the emerging image from a distance, because tonal variations that are virtually imperceptible close up can be ascertained more clearly across the composition from further away. Try to avoid the temptation to draw in too much detail – it takes confidence to leave large areas of relatively flat value, but it's what we want for this piece.

Don't be surprised if this stage takes longer than you think it should – it's a very subtle process. If you get it slightly wrong, simply add another layer of charcoal or remove it with a soft cloth or blending paper until you get the effect you want. Bear in mind the atmospheric perspective in the scene (see page 25); generally speaking, the further away elements are in the landscape, the more subdued the values will be.

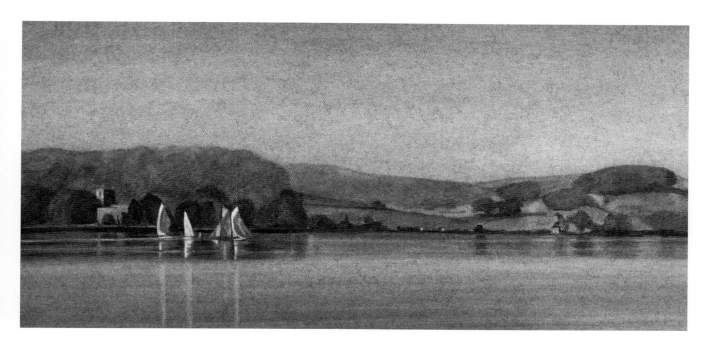

STAGE 5

This stage is all about subtractive drawing and sharpening up. You will use erasers, paintbrushes and a soft cloth to reveal the highlights and to produce the effect of ripples on the water. Starting with the sails of the boats, use an eraser to lighten the lightest parts of the sails and their reflections. Notice that the sails are spherical forms, so there is a graduated transition and they are not universally light.

Next, use paintbrushes to gently suggest foliage in the wooded areas and to lighten the more distant landscape to suggest atmospheric perspective. For the foliage, hold a watercolour fan paintbrush like a conductor's baton, with the curve of the bristles facing upwards, and very gently press the brush against the wooded areas. When you pull it away, you should notice a very slightly lighter area in the shape of the brush.

For the distant edges of the woods, where they appear to melt away into the background, use a paintbrush with long, soft hairs, because it will enable you to remove charcoal very delicately until the edge just blends in with the background.

The final phase is to use a cloth to suggest ripples in the water as well as the more subtle reflections of the sails in the lower part of the image. When you lift out the ripples, it will be easier to maintain a controlled line if you turn the drawing on its side and draw them from top to bottom. Notice that the spacing between the ripples gets slightly wider the closer they are to the viewer's position, thereby following the rules of diminution and adding to the illusion of depth.

Use the shape of a paintbrush with a narrow row of bristles, such as this watercolour fan paintbrush, to gently lift off the charcoal to create the illusion of foliage.

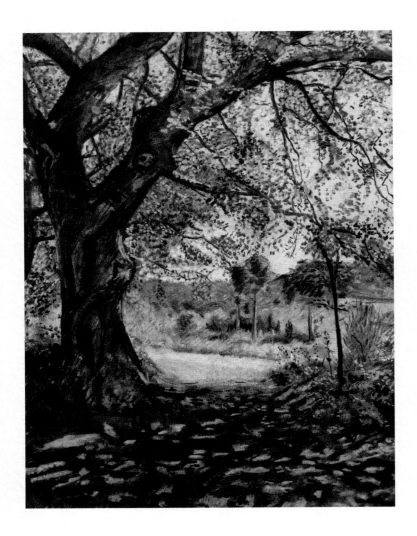

Landscape Sketch

It's time to gather up some equipment and head outdoors.
In this tutorial you will work with a basic set of materials to create a landscape drawing.

YOU WILL NEED

a sheet of good-quality drawing paper • a drawing board of a suitable size and clips
• a field easel (if you will be standing) • some thin to medium-thick natural charcoal sticks
• a soft cloth • a selection of erasers, including a super-fine pencil eraser • workable fixative

Although working at home or in a studio has its advantages when it comes to producing finely finished works of art, there is nothing quite like packing up a backpack and heading out to draw in the great outdoors – or, to use the correct art term, to work *plein-air*.

However, working *plein-air* can present some particular challenges. To begin with, you will have to carry everything you need to work with, and if you will be carrying your equipment for some distance, you will want to pack as light as possible. Another consideration is that unless you plan to return to the same spot to continue drawing another day, you will have a limited time to complete your work, so you will need to work quite quickly. Finally, the light will shift as you are working and the weather can be unpredictable. If you are happy to accept these factors, then you will find that drawing *plein-air* is fun and rewarding.

For this drawing, I had a particular spot in mind – a lovely old hazel tree next to a path with some interesting terrain falling away to provide the background. I decided to travel light, so I took a lightweight field easel and drawing board along with just basic materials.

Setting up

Your first task will be to find a suitable spot. Because it can take some time and effort to find a scene that you want to draw, it will help if you can reconnoitre a suitable drawing site before heading out with all of your kit. Look for a scene

that you find interesting, think about how it would look on the paper (see Composition, pages 26–27) and consider the practical issues of what will be involved to make your sketch. Is there a suitable spot for you to set up an easel or for you to sit with your drawing board? What will the lighting be like during the day – as the sun moves is there a large object nearby, such as a tree or building, that would cast shadows on your scene for only part of the day? What is the weather forecast for the day you want to sketch? If a sunny morning turns into a cloudy afternoon, the lighting could change more dramatically for your drawing than just a shifting sun – and the last thing you want is to be in the middle of a drawing and have it ruined by rain.

When setting up an easel, look for a spot where the ground is level but you still have a good view of your subject matter.

Tip
Draw a slightly wider perspective than you want your final image to be. This will allow you to make a final compositional crop later on and to have some paper on which to overlap a mount if you decide to frame it.

STAGE 1

Begin by getting some charcoal onto your paper using a stick of natural charcoal dragged on its side (see page 20). Your aim is to have a nice even sky as a background that will contrast the darker shapes in the foreground. Even if you think a clear sky looks light enough to leave it as white on your paper, it is almost certainly darker than you think, so don't be too timid in producing a nice light grey all over.

Before you start plotting the main elements, you need to think about your composition. In this case, the horizon line is just below halfway up the image and the main element – the tree – dominates the left-hand side, while some undergrowth on the opposite side of the path provides some balance. The trees in the middle ground are intended to draw your gaze through the foreground and down the pathway.

Using a thin piece of charcoal, draw the main elements of your composition in but don't include all of the detail – you just want them there as points of reference from which to work out the position of other elements as the drawing progresses.

Once you situate the line where your background meets the sky, lighten the area along it slightly. This will emphasize the contrast between it and the background when you draw it in.

Tip
When drawing outdoors, clips can be more useful than tape to secure your paper to the drawing board. By using clips, you can turn the finished (and fixed) work around and clip it with the image facing inwards to protect it from accidental knocks and to stop it from rubbing against other surfaces.

STAGE 2

This stage is about sketching in the middle ground. Draw this whole section quickly and loosely to produce an impressionistic rendering of the scene, using basic hatching and cross-hatching techniques (see page 15).

Start by working from the back, where the trees meet the skyline, and sketch in the outline of the trees in the furthest distance. Gradually work forwards to the patch of undergrowth with the trees in the centre. Don't spend too long adding fine details to this area – they would only need to be adjusted at a later stage – but do get a reasonable idea of where the main elements are located and of the main values. This is so that you will have something to contrast the foreground against and because you will need to draw foliage over the top of this area.

If in doubt about how light or dark to make the middle ground, leave it slightly darker. You can always knock the value back later on with subtractive drawing (see page 19).

Tip
Observe your own composition so you don't waste time drawing in areas where the middle ground will largely be obscured by the foregrounds – in the example here, these are the areas to the extreme left and right in the middle ground.

STAGE 3

You are now ready to block in the main area of darker value in the foreground. This whole area is in shadow and provides contrast to the middle ground, which pushes it back visually and enhances the illusion of depth. Block in everywhere that you perceive is significantly darker than the middle ground. Don't worry that there are lighter patches or details within these areas – you will add these with subtractive drawing later on.

Judging large areas of value can be harder to do than it sounds, because you may be so used to looking at details that you simply don't notice them. Colour can also confuse your sense of value, so you have to actually look at the scene as a whole and analyse specifically for this factor. In this case, the shadow area is a major part of the composition and darkening the foreground will make the middle ground look brighter and more inviting, making you want to walk down the path and step out into it.

Shade in the tree trunk and the undergrowth on the right-hand side, including some detail of the plants silhouetted against the centre ground. Now draw in the branches without taking too much time to get them in exactly the right place. All you are after is an impression, so work quickly and loosely.

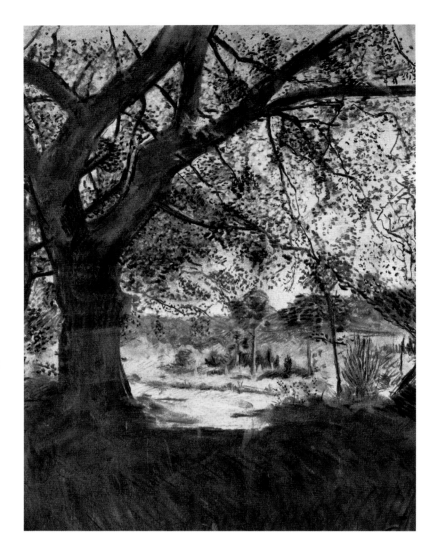

You can now start drawing in the foliage using a stippling technique (see page 15). At first glance the leaves look like dark silhouettes against the lighter background; however, there are quite significant differences in value within the foliage, so you will need to work in layers to give the impression of depth. Smudge each layer very slightly before working over the top with a further layer of stippled marks.

For the first charcoal layer of foliage, identify any areas where the clear sky is completely obscured by a mass of leaves, then lightly draw these areas with charcoal and blend them to be a little darker than the sky behind it. Now use the stippling technique to hammer dots of charcoal onto the paper wherever you can see leaves, using slightly different thicknesses of charcoal to vary the effect.

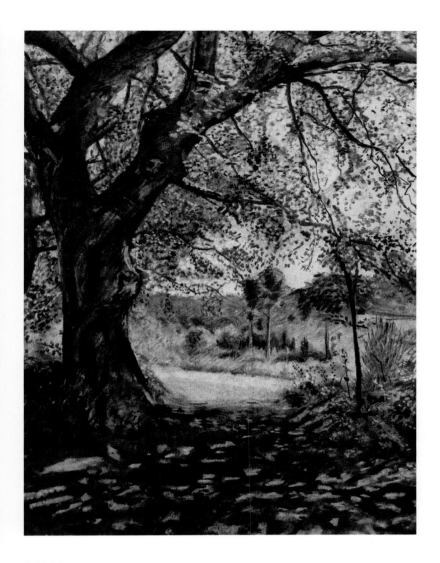

If you have an electric eraser, it is the perfect tool to capture spots of light in foliage and to create texture.

STAGE 4

Having used charcoal to stipple dark marks onto the paper, you will now use the same hammering movement but with a super-fine eraser for subtractive drawing. Your aim is to break up the leaf patterns and increase the sense of depth in the foliage. However, if you feel the foliage needs more dark charcoal, you can continue to add charcoal in between layers of subtractive stippling.

Once the foliage looks right, continue with subtractive drawing to rub away the areas where the sun is breaking through to create a pattern of dappled light. You can also use subtractive drawing to add the detail of undergrowth on the right-hand side and around the base of the tree.

As the work is nearing completion, take a moment to assess the general balance of values and details across the piece. If necessary, use an eraser to very lightly blend the surface of the middle ground to knock it further back into the distance, using the principle of atmospheric perspective (see page 25).

Once this step is complete, you will probably find that the values range is still quite narrow and your darks aren't dark enough to really make the lighter background stand out. The solution to this is to fix the drawing with a working fixative (see pages 12–13), allow it to dry and then work over your darks in the foreground. This should enable you to get a significantly darker foreground and to make the contrasting lighter areas really stand out.

Sailing Ship

Combining compressed charcoal together with natural charcoal
can produce beautiful results, which will be the focus in this tutorial.

YOU WILL NEED

a sheet of good-quality heavyweight cartridge paper • a fine-line black pen or sharp waxy pencil • tracing paper (optional) • a ruler or other straight edge • a good-quality compressed charcoal pencil • medium-thick natural charcoal sticks • charcoal powder • a soft cloth • a kneaded eraser • a pencil eraser • blending stumps • a mahlstick or wooden battens (see page 65)

The reference material for this artwork is an old photograph of a 19th-century racing yacht. It is such a special image that I decided to try to recreate it in charcoal. In doing so, I realized that it is an excellent image for teaching key lessons in charcoal drawing – which is why it frequently makes an appearance when I am running workshops or drawing demonstrations.

What I love about this piece is that it's actually quite simple to produce, but there are a couple of stages when something magical happens: first when you blend the waves to create a watery effect, and again when you reveal the white of the sails by removing charcoal with subtractive drawing (see page 19). When people first see this image, they often assume that I've used a white pigment to do the areas of lighter tone, but these are merely areas of exposed white paper. They help to hold elements in the drawing together visually and add to the sense of simplicity and tranquillity in the image.

Scaling up the boat

There are three yachts in the original photograph, but I decided to concentrate on just one – the yacht in the centre – for the drawing. I used a camera to take a digital copy and then cropped the image on my computer. From this, I produced a scaled-up image from which I could trace my initial outline. If you don't have a computer but do have access to a photocopier, you can use it instead to enlarge the image. Or if neither is available, you can use the grid system (see page 89) or proportional dividers (see page 22) to sketch out an enlarged boat.

Once you have an enlarged image, you can copy the outline onto tracing paper, first by positioning the tracing paper over the ship and tracing it with a pencil, and then rubbing charcoal onto the opposite side of the tracing paper where the pencil lines show through. Now you can position the tracing paper, with pencil marks facing up, over your drawing paper where you want the boat to be placed and draw over the pencil marks with your pencil once again. By using a coloured pencil, it will be easier to see where you have already traced over the original pencil marks.

Picture plates found in old books can provide interesting reference material for a charcoal drawing. Sepia and black-and-white illustrations make it easier to ascertain the tonal values.

When using tracing paper to transfer an image onto your drawing surface, remember the image will be reversed (flipped horizontally). Make sure you take this into account when you make your compositional decisions.

STAGE 1

Begin by tracing or marking out the outline of the boat with a thin black pen or sharp, waxy pencil. If you are using tracing paper, position it over the charcoal paper and tape or otherwise secure it in place to the drawing board to avoid marking the drawing paper.

You can use a ruler or other straight edge to get the mast and spars (thin long poles) absolutely straight. Instead of drawing the curves of the sails by moving your hand from your wrist, use your arm as a pivot point to draw the slight curves. However, note that you should not mark the line for the sails all the way around: the areas where the sails meet the sky on the right-hand side are close in value to the greys in the sky, so these areas will bleed into each other. Where the sails at the front of the ship meet the sky on the left-hand side, the tonal delineation will be light, so you will be marking out these lines later with an eraser. Regardless, you do need to make sure that you mark the start and end points of the sails to act as a guide for when you will be drawing them in.

It is a good idea to also include some of the rigging at this stage, because it will be difficult to add it later on, and the thin pen you used for marking the outline is more suitable for this task.

As you start to mark in the waves, remember that waves conform to the rules of perspective (see pages 24–25), so the waves at the front will be larger and more spaced out than those in the distance. Notice how the reflection of the ship in the water is darker in the centre section, so add more waves here to increase the density.

Tip

You can trace out the waves at this stage, as I have done here, or you can skip this laborious process and mark them in directly with compressed charcoal during the next stage. They don't need to be placed exactly to create the illusion of water and should look fine as long as you remember that waves conform to the rules of perspective.

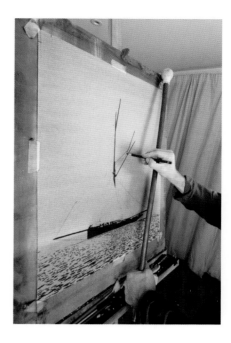

Tip

I'm using a homemade mahlstick, made from an old walking stick. I've padded out the end so it is wide enough to rest against the board without the walking stick touching the drawing. By holding it steady, my drawing hand can rest on it for support, allowing for more controlled drawing and preventing smudges.

STAGE 2

You now need to add a light grey background to your drawing. To do this, lay your drawing flat and cover the whole image in charcoal powder before working it into the grain of the drawing paper with a soft cloth (see page 20). Your aim is to create a nice and even tone. However, the horizon line should be ever so slightly lighter to create the impression of a slight sea mist – use a clean portion of the cloth to wipe away a little charcoal in this area, but only where you know the sails of the ship will not obscure the horizon.

Using a sharpened compressed charcoal pencil, carefully shade in the silhouette of the hull and the mast and spars. Keep sharpening the pencil as often as necessary to maintain nice sharp lines on the mast and spars. During this step, you will need to be careful to avoid accidentally smudging the grey background, so I suggest using something to lean on. The ideal tool for this is a mahlstick (see page 13).

Now start shading in the ripples on the water as solid shapes – don't attempt to draw them as three-dimensional forms yet, just as dark shapes.

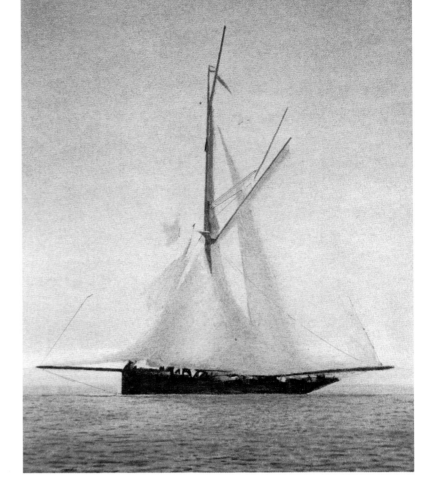

When blending the waves, ensure that you move the paper stump horizontally, going in the same direction as the waves.

STAGE 3

The waves drawn in as dark shapes in the previous stage have hard edges that now need softening so they appear more watery against the lighter background. Rub the blender vigorously from side to side, and try to keep your movements parallel to the horizon to accentuate the linear pattern of the waves.

Notice that when you use the blender, it will pick up some of the compressed charcoal and carry it across the paper, so the areas you've drawn become a bit lighter and the light grey background becomes a bit darker. This is exactly what you want. You can see now why it was important to use a good-quality compressed charcoal pencil that adheres well to the paper.

Now look carefully at the sails and determine where you need to add tonal value. Choose a long piece of natural charcoal and prepare the drawing end by flattening it against a piece of scrap paper or a sanding block. Hold it right at the end to minimize the amount of pressure you apply and very gently start adding value, being careful not add too much too soon. As you do this, you will probably have to move to different positions around your artwork to draw from the right angle. It is not absolutely necessary, but if it helps to use the mahlstick, you can do so.

Using a blending stump, gently blend in the charcoal you've added to remove the drawing marks and work the charcoal into the grain of the paper. Ideally, you should use a different blending stump from the one you used to blend the darker compressed charcoal or you should clean your blending stump before using it.

STAGE 4

You are now at the exciting part where you use subtractive drawing and wiping to reveal the white of the sails. For this stage, you will need erasers and a clean soft cloth. If you are working upright, lay the work flat again and clear some space around the drawing. You will need a piece of batten or other long thin strip of wood or metal to act as a ruler to get your lines straight, and you will also need a way of keeping your ruler off the drawing paper. My preferred method is to use three pieces of batten (see below right). The arrangement will allow you to keep the ruler about 1in (25mm) off the paper. Select an eraser that you can run along your ruler to produce a neat line. If you have a stick eraser, it would be ideal, but a standard pencil eraser at the end of a graphite pencil works well, too.

Align the straight edge carefully with the marks on your drawing, making sure you allow for the width of the eraser. Lean forward to ensure that your eyes are directly above the line you are drawing and erase along the line, being careful to keep the eraser straight all the way along. You can now use other erasers and the cloth to gently reveal the white paper in the areas where the light is falling directly on the sails. Try to avoid using erasers with square edges – if necessary, rub the eraser edge on a piece of coarse-textured cloth to soften the edges, because this will help you to make a smooth transition between different areas of tonal value.

The final step is to lightly erase along the top of some of the waves to enhance the illusion of three dimensions, and your drawing is complete.

Two pieces of batten placed along the edges of the work support the third batten (being used as a ruler) above the drawing to prevent smudging it.

FOCUS ON
Preserving Your Work

The uniquely delicate properties of charcoal mean that you need to think carefully about how to preserve your work for the future. The normal practice is first to 'fix' the image using fixative sprays and then to frame the image behind glass. However, if you are not ready to frame your work just yet, you will need to know the best way to store it.

Spray fixatives

When choosing a fixative, make sure you read the product description carefully. If you want your work to last for many years, you should choose one that is specifically of archival quality and specially designed to preserve the work for a long time.

Before applying a fixative, be sure that the work is completely finished (with a signature if you are including one). Then make sure there are no obvious loose particles or flecks of eraser on the paper. Using a light from the side can help you see any problem areas. If necessary, tap the easel or drawing board or use a small brush to very carefully remove any debris.

Modern fixatives are less noxious than they used to be, but I strongly recommend you take measures to avoid inhaling the fumes as you spray. Work outdoors if you can, but if this is not practical, spray it in a well-ventilated space. If you need to protect the floor, make sure you place old newspapers or something similar around the area where you will be spraying.

Now, keeping your drawing taped or clipped to your drawing board to stop the paper flapping around and dislodging loose charcoal particles, move it to your spraying area. Lay it flat, or at a slight angle, but not upright.

Hold the spray can perpendicular to the drawing and let the fixative mist drift onto it from a distance.

A sheet of glassine paper is placed over a charcoal drawing being stored on mount board.

The golden rule when applying a fixative is that several light layers are always better than one heavy one. The spray will be pressurized when it comes out of the can, so if you hold it too close to the paper, there is a risk that it will blow away some of your charcoal details. Another risk is that you might saturate the drawing paper with too much of the liquid spray, which can reduce definition.

The first stage, therefore, is to create a light mist of the fixative from a distance and allow it to fall gently onto the drawing paper. Start in one corner and work in a crisscross pattern to ensure the whole area of the paper is covered. Be patient and let it dry for at least 10 minutes before spraying the next layer. In the second pass, do the same but at right angles to the direction you just sprayed.

Once the first couple of layers have dried, you can go a little closer, but you should never hold the can closer than about 12in (30cm) from the paper. Allow the drawing to dry for at least half an hour before proceeding to framing or storing the artwork.

Framing

The best way to preserve your work is to place it behind a sheet of glass. It is important, however, that the charcoal itself does not actually touch the glass, so the conventional method is to place the work behind a piece of mount board with a window cut out of it. Together with the choice of frame, this mount board should be considered an integral part of the design of the finished artwork and can greatly enhance its appearance.

I recommend you use the services of a professional framer. Although more expensive, a professional is appropriately skilled and equipped to do a good job and can provide excellent advice on how to present your work in the best possible way.

Storing your work

If you do not plan to frame your work immediately, you should still apply a fixative, but once it is dry, tape it flat to a piece of mount board or foam board before laying a sheet of glassine paper over the top of it. Glassine paper has an antistatic quality and is very smooth, so there is less risk that areas of the image will be rubbed away. As with every product you use to frame or store your images, it should be of archival quality – in other words, pH neutral and acid free.

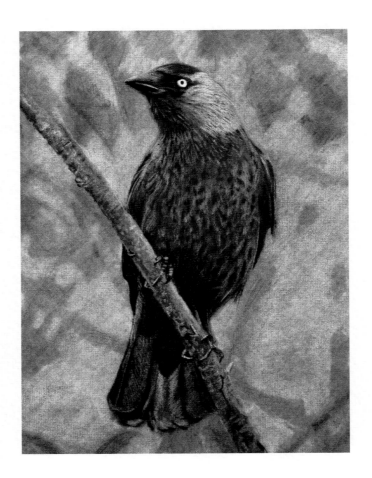

Jackdaw

Birds are delightful creatures to draw – and their feathery coats
present us with some nice drawing challenges. In this tutorial you will
discover that it is relatively easy to achieve effective results by
using some simple techniques and basic equipment.

YOU WILL NEED

a good-quality heavyweight cartridge paper • a good-quality compressed charcoal pencil
• some thin to medium-thick natural charcoal sticks • a kneaded eraser • blending stumps
• a soft cloth (optional) • a super-fine pencil eraser or the eraser on a standard graphite pencil

One thought that may have occurred by now is that with a relatively small number of techniques you can tackle just about any subject matter. Earlier in the book, the technique of combining compressed charcoal with natural charcoal successfully created the effect of ripples on water (see Sailing Ship, pages 60–65). In this tutorial, you will be using the same fundamental technique but will take the process a little further to achieve the effect of feathers.

As stated previously, the quality of your compressed charcoal pencil can make a big difference to the results you get, and this is particularly true for this project. Make sure you choose one that will adhere well to paper, because you don't want the marks to be smudged too easily when you start blending.

The background in the reference photograph is already blurred, but I blurred it even more in the drawing to focus on the bird. The leaves are suggested but not drawn in as dark and detailed.

Tip
When drawing from a source material such as a photograph, it helps to clip it to your drawing board for ease of reference when adding the final details.

Choosing your source

I wanted to draw a jackdaw as I felt that its monochrome plumage and grey neck feathers would work well in charcoal. Jackdaws are also one of my favourite breeds of bird and occasionally visit my garden, so I decided to try to capture something I could work with on my camera. Having placed some bird food in a tree opposite a window, I patiently waited and was eventually rewarded with a visit from this fine specimen. If you struggle to produce your own source image, you could look for an image online. Try to find one that shows a good amount of detail in the feathers, so you can practise the techniques set out in this tutorial.

One of the goals of this piece is to create a contrast between the detailed bird and simple background. Take a few moments to compose your artwork. Here, the bird is in the centre with an even amount of space all around it, and the diagonal branch it is clinging to provides a nice dynamic element to the composition.

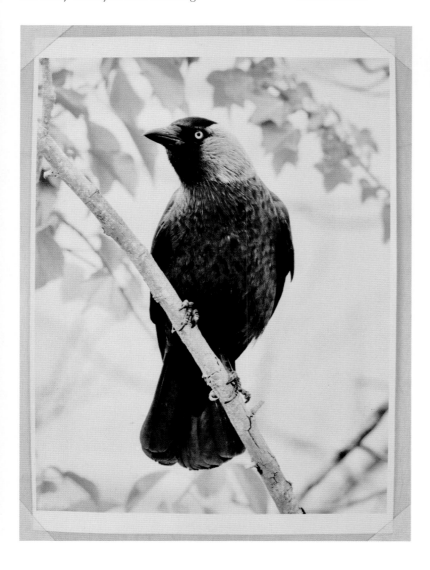

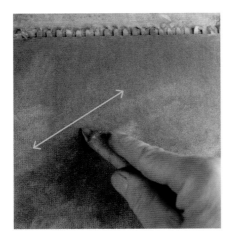

When blurring a background, it helps to use a large blending stump, using long strokes while pressing it hard.

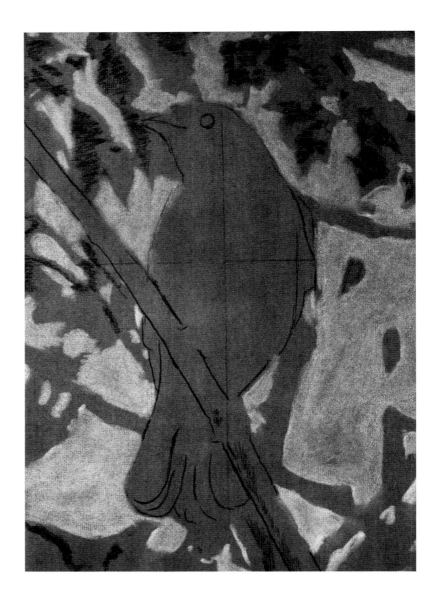

STAGE 1

The first step is to prepare your drawing paper. Using charcoal powder, if you have it or, failing that, a stick of natural charcoal held on its side, cover the whole sheet of paper with charcoal (see page 20). Now you can work it into the paper until you have a reasonably even grey mid-tone all over.

Once your mid-tone layer is ready, use a piece of thin natural charcoal to draw the outline of the bird as well as the leaves and branches in the background. Using an eraser, gently remove the lighter areas of the background. Using an eraser with rounded edges is the most effective way to create the impression that the background is slightly out of focus and blurred. If necessary, you can further soften the edges and remove any marks with a soft cloth, but don't go too light too soon. Don't cut all the way back to the white of the paper, but do remove enough to break up the large expanse of grey.

The next step is to identify where your background needs to be slightly darker than the mid-tone and add natural charcoal where necessary. Note that you don't need to do anything to the bird at this stage.

STAGE 2

You can now blend in the background with a blending stump so that it further softens the edges, which will increase the illusion of the background being out of focus. Use broad strokes from side to side and have confidence to press quite hard so that the darker areas become lighter and the lighter areas become darker. You can adjust the background again later on after the bird is draw in – at which time you will better see how well the two elements of the drawing work against one another – so there's no need to spend too long on this step.

The next step is to draw in a layer of darks with a sharpened compressed charcoal pencil. As you do this, keep referring back to the source image and take your time to draw as accurately as possible, because once compressed charcoal is applied, it is more difficult to go back.

Drawing on the surface of the paper and carefully leaving areas untouched where you want your lighter values, start shading in the clearly defined darker feathers on the bird. While doing this, try to make your marks in the direction of the feathers, which will help enhance the illusion of reality in the finished drawing. Bear in mind that these areas will go darker when you work the compressed charcoal into the paper during the blending process, so don't go too dark too soon; you can always add more later. Because you are working in the centre of a piece of work you may find it helps to draw accurately if you use a mahlstick (see page 13) or a suitable alternative during this phase.

Once you judge that you've added enough compressed charcoal to the bird, move on to the main branch that the bird is sitting on and continue using the compressed charcoal pencil to add some detail. Again, avoid adding any compressed charcoal to the background to keep the foreground and background quite distinct from one another.

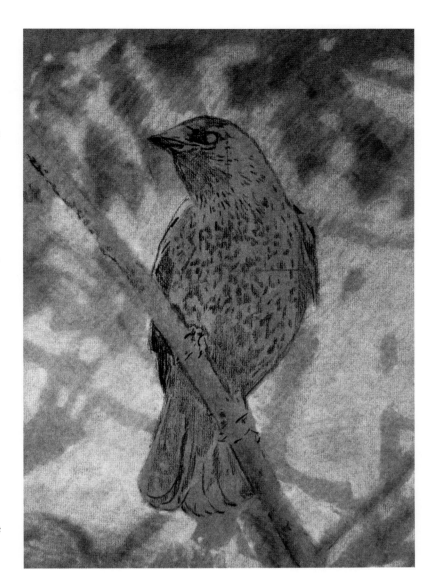

Tip
For images with plenty of fine detail, such as the feathers on this bird, it is better to work on a scale larger than life size, which lessens the limitations of your tools and materials when drawing on a small scale.

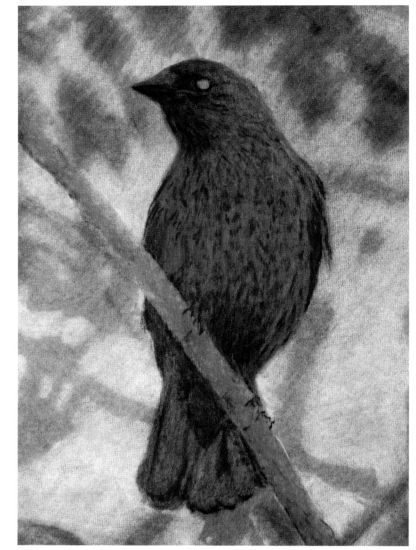

You can define the feet by drawing with a sharpened compressed charcoal pencil, but don't be tempted to draw a black line around every claw or to make them the same value throughout – like every other part of the image, they are a mixture of highlights and shadows.

STAGE 3

At this point, you can blend in the compressed charcoal marked in the previous stage and add any additional compressed charcoal as required to get your darkest darks to the values you want. Using a small to medium-sized blending stump, work the compressed charcoal into the paper in a motion that contours the form of the bird. Try to be reasonably neat around the edges of the bird – however, you will have the opportunity to tidy these areas up later on.

The next stage is to work subtractively (by removing charcoal) to add detail, but for this to work effectively, you need to add plenty of natural charcoal on the paper to have something to subtract from. Using a reasonably thin piece of natural charcoal, cover the entire area of the bird – with the exception of the eye – with charcoal, working it into the weave of the paper.

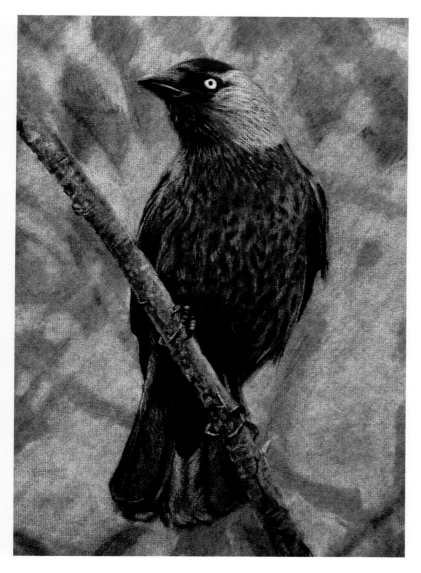

STAGE 4

You are now in a position to add detail with subtractive drawing. For the first part of this stage, it is best to use a kneaded eraser. You should avoid rubbing all the way back to the white of the paper, and kneaded erasers are better at this task because they are softer than other erasers and there is less chance of removing too much medium by accident.

Your aim is to lighten the value slightly in the right places and simulate the texture of feathers. You also want to enhance the impression of a three-dimensional form by adding highlights and shadows. For the lightest highlights, you will find a super-fine pencil eraser is convenient for applying more pressure and replicating the very fine feathers around the back of the head, the beak and the tail feathers, helping to show their transparency. A key point is that you don't need to draw in every detail of every feather. An occasional fine light or dark line here or there will be enough to suggest the illusion of feathers. You should also use a super-fine pencil eraser to work in some detail on the branch and the bird's claws. You can add any darker detail with a finely sharpened pencil.

The final touch is to draw in the eye. Clearly defining an eye always helps when drawing animals. Begin by erasing the white portion of the eye to expose as much of the white of the paper as you can. You will inevitably produce a slightly blurred edge when doing this, so you should then re-emphasize a sharp edge of contrast around the eye using a sharpened compressed charcoal pencil. Then add the black pupil.

Tip

For the areas where you need to produce a fine highlight, you will need to form a narrow erasing edge with which to make your marks. The best way to do this is to pinch the end of a kneaded eraser to form a ridge rather than a point. This is because a point will not be strong enough to rub away the medium.

Alternatively, you can shape the eraser at the end of a standard graphite pencil using a sharp knife to form a narrow edge.

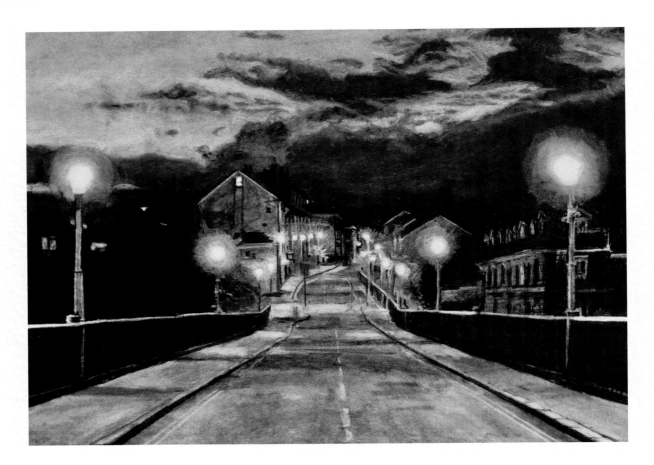

Chiaroscuro Night Scene

This tutorial will require you to use the widest possible values range to produce a night scene with bright highlights and deep shadows.

YOU WILL NEED

a sheet of good-quality heavyweight bright white cartridge paper • some thin to medium-thick natural charcoal sticks • compressed charcoal in block and pencil form • blending stumps • a soft cloth • various erasers, including a super-fine pencil eraser

'Chiaroscuro' is an Italian word that literally means 'light and dark'. Artists use it as a term to describe scenes that have a very strong contrast between light and dark – in particular in scenes where some of the detail is lost into the shadows. As a technique, it came to prominence in the Renaissance period of the 14th–16th centuries, when it was often used in figurative or still-life paintings, but it can be applied to any genre.

For this tutorial, you will be producing a street scene with streetlights against a dynamic background of dark clouds. The view is of the Iron Bridge in my home city of Exeter, England. The old lanterns on the bridge have been converted to electricity since it was built in 1834, but otherwise it is a scene that has changed very little in nearly 200 years.

Your aim is to make the lights look like they are shining brightly, so choose a sheet of paper that is a nice bright white. You also want to achieve some deep black darks, so you will be using compressed charcoal to achieve these.

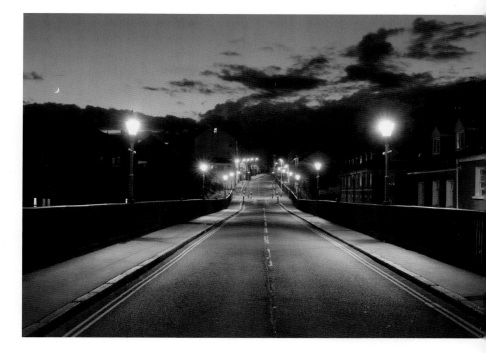

The original photograph before being cropped, converted to monochrome and adjusted to enhance the contrast slightly.

To get the main elements in the photograph, such as the bridge, streetlights and clouds, onto paper, you can trace them (see page 61) or use observational drawing techniques (see pages 21–23).

Choosing an image

If you want to work from your own reference material, choose a nice, sharp photograph. Night-time photography takes some effort to get good results. Before heading outdoors, check both the weather forecast and phase of the moon, which can have an impact on the photograph. Generally speaking, a current digital camera will produce better results than a smartphone. Both should have a setting for shooting at night that defaults to a slow shutter speed, which means you will have a blurred image if you try to take your shot by hand. For a good crisp image, it is critical that the camera is absolutely still throughout the shot. Ideally, use a camera tripod, or place the camera on something static. Use a timer setting or remote shutter release so that you do not touch the camera at all while the image is being taken.

You should think about the composition (see pages 26–27), especially if you plan to take your own photograph, or how you want to crop the image. I placed the point at which the road disappears into the horizon at the centre of the piece to provide symmetry and balance. Notice that the road conforms to single-point perspective (see page 24) and that the lights get smaller in accordance with diminution.

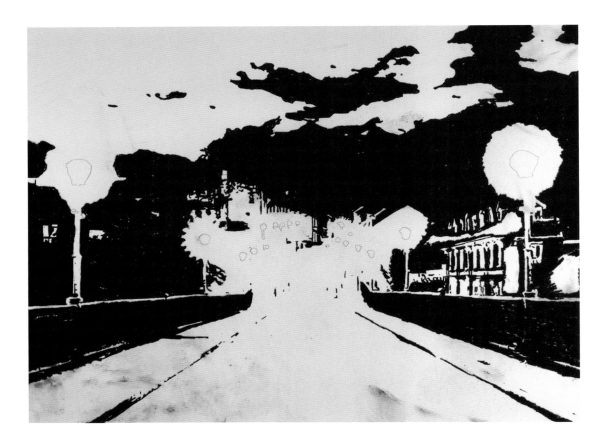

STAGE 1

Because compressed charcoal pencils are more expensive than blocks of compressed charcoal, use the pencils to outline the shapes and the blocks to fill in the larger areas.

To give the impression that the streetlights are shining, you should avoid getting any charcoal into the areas of your lightest lights, so use a graphite pencil to mark the areas you want to keep free of charcoal. Even with this precaution, charcoal dust will still settle on the surface of these areas as you work. However, you don't need to be overly concerned – as long as you do not rub the particles into the weave of the paper, you can blow them away or erase them at the end of the drawing process.

Again using a graphite pencil, mark off everywhere you want your darkest darks to be. Now fill these areas in with compressed charcoal and then blend it into the paper using your fingers or a blending stump. In this stage, you are applying the principle of blocking in value at the start of a drawing without worrying about trying to get the detailed values correct – these will be adjusted later. Normally, you would only apply compressed charcoal where you want your darkest darks, because it is harder to lighten areas drawn with compressed charcoal than areas drawn with natural charcoal. In this piece, however, you want the dark clouds to be virtually silhouetted against the sky and the outline of the buildings to be virtually outlined against the dark clouds. This will require some subtle adjustments later on, but for now just get the material on the paper.

Notice that I have accidentally smudged some compressed charcoal onto the paper in the foreground while I worked on the upper section (I could have avoided this by using a mahlstick, see page 13). I plan to cover this area with natural charcoal, so I will work over it later on – and using an eraser at this point could make it worse.

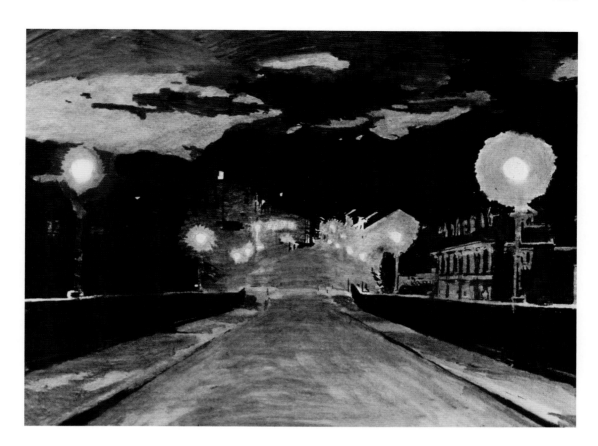

Tip
Remember the principle of simultaneous contrast (see page 16) – you can make lights appear lighter by increasing the relative darkness of the things around them.

STAGE 2

The aim in this stage is to block in the main areas of value, which means getting plenty of natural charcoal (and only natural charcoal) onto your paper so that you have enough to subtract from later. Starting with the areas around the streetlights, draw up to the pencil lines, leaving the lightest lights completely free of charcoal. These areas are now more obvious, so there should be less risk of accidentally drawing over them. Get into the habit of layering on charcoal and then blending it in until you are close to the value where you want it to be. You can adjust it later on by going lighter or darker, so it is not critical to get it absolutely correct at this stage. However, the closer you are, the easier it will be to make more subtle values judgements when you start drawing in the detail.

Make sure you apply plenty of natural charcoal to the area of the sky. It may look light in relation to the darker elements in front of it, but the sky is still dark when compared to your lightest lights.

Remember that the sky is generally lighter closer to the horizon, so don't hold back from applying plenty of medium at the top of the image. You will have lots of loose charcoal sitting on the surface of the paper that you can work in and manipulate in the next stage.

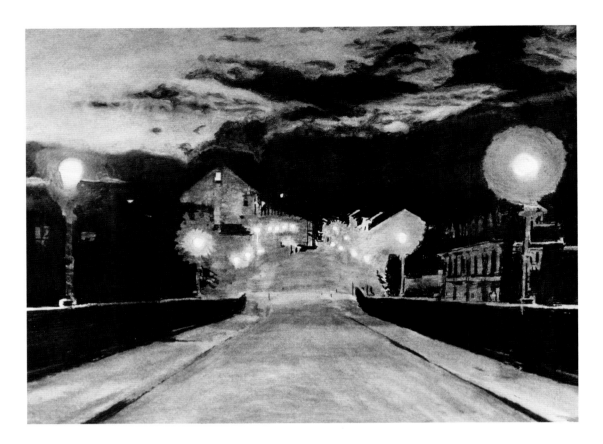

Tip

Bear in mind that clouds conform to both linear and atmospheric perspective (see page 25), so not only do they get smaller towards a vanishing point but they will also be less clearly defined.

STAGE 3

This stage is fiddly and will take some time to get right, but it is fun and satisfying. It is all about getting the sky to look right. You should always try to work from the back forwards so that you are adding visual layers. At a glance, the clouds just look like a mass of black shapes against the sky, but if you look closely, they are quite transparent and wispy in parts. You will also notice that the buildings on the skyline are just about silhouetted against the mass of dark cloud in the centre of the image.

Start by blending in the natural charcoal you added in the upper part of the sky during the last stage. Blend it into the paper with a soft cloth folded into a pad, using a circular motion and simply working over the top of the compressed charcoal cloud masses, until the lighter areas of the sky are nice and even – and slightly lighter in the lower part.

Use a blending stump to soften the edges of the clouds by using a small circular motion that lifts some of the medium away and deposits it on the surface of the paper. If you need to lighten larger areas, use a soft cloth wrapped around your finger and press hard to wipe the medium away. For the smaller clouds, you can use a blending stump to 'draw' using compressed charcoal lifted away from other parts. You can also use erasers and thin pieces of natural charcoal to lighten or darken your tonal values as necessary. Finish this stage by lightening the sky behind the buildings very slightly with a soft cloth.

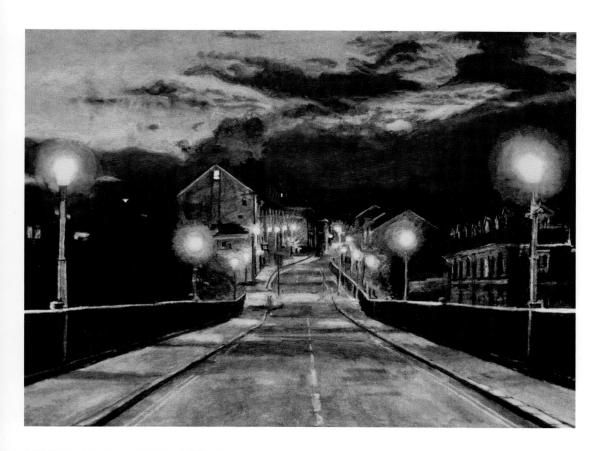

STAGE 4

The final stage is about adding detail, refining tonal values and sharpening up the drawing. Just as before, start at the back and work forwards. Begin by drawing in the silhouettes of the buildings on the horizon using a compressed charcoal pencil. Now use natural charcoal to draw in detail, such as the posts of the streetlights, the shadow areas thrown across the road, the flagstones and the glow around the streetlights.

Once you feel you have taken the additive drawing as far as you can, switch to subtractive drawing using erasers. A super-fine pencil eraser will allow you to draw in the lines on the road and the highlights on the rails. You can also use it to very lightly draw vertical lines in the railing on either side of the road. You don't have to draw every single one of them, and they only need to be hinted at – they should provide enough of a visual clue so that people can tell what it is.

The final stage is to erase any medium that is lodged on the lightest lights in the centre of your streetlights. A mechanical eraser is useful here, but use whatever you have.

Tip

When drawing highlights, such as on the lightest parts of the railings, you can emphasize the apparent glow by drawing the lighter line a little wider than it actually is.

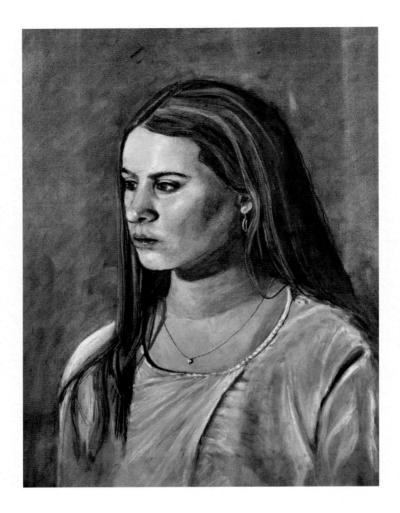

Portrait

The grey coloured paper used in this tutorial provides the ground for drawing a portrait, and you will also be adding white for your highlights.

YOU WILL NEED

a good-quality, smooth-textured, mid-tone coloured pastel paper
• thin to medium-thick natural charcoal sticks • a white charcoal pencil
• blending stumps • a soft cloth

Portraits can be intimidating because most people are understandably self-conscious about their drawing abilities. Nevertheless, they are excellent for drawing practice and it can be tremendously rewarding when you capture someone's likeness. A self-portrait is another viable alternative and easy to set up – all you need is your drawing materials and equipment along with a mirror.

Drawing on coloured paper

The method of drawing on coloured paper in a mid-tone and then using a combination of lighter and darker mediums to achieve your final image has been used for centuries. In this tutorial, you will apply this technique to a portrait, but it could be used for any subject matter. Conversely, it is not necessary to use this technique when drawing a portrait; you could just as easily draw straight onto white paper and dispense with the white pigment.

I have chosen a grey paper for my drawing but you could use any earth tone with a roughly middle tonal value. Because you will be using a coloured paper in a mid-tone, you will need a white medium to achieve highlights in white.

I asked my daughter to act as my model and have gone for a classic three-quarters pose but you could choose to draw the model's face straight on. You can do the underdrawing as either a sketch or as a measured drawing. If you want to take portrait drawing further, there are several established approaches to portrait drawing that you can research and learn.

Setting up

Ask your model to wear something suitable. My daughter wore a loose white blouse that would allow me to exploit the use of the white pigment.

If you expect the drawing to take some time, it is important to ensure that your model is comfortable and can hold the pose without any physical stress. For this exercise, I placed my model in a comfortable chair and set up a laptop computer with a film for her to watch, which not only kept her entertained, but also ensured that her gaze remained constant.

Use a portable light source to illuminate the face from the side, so that strong shadows emphasize the form of the head. Set up your drawing position so that you can alternate your gaze between the drawing and model without strain.

Tip
Your model will probably need to get up and move around from time to time, so make sure it will be easy for them to adopt the same position again afterwards. I took a couple of snapshots of her position in the chair so that we could create it again when required.

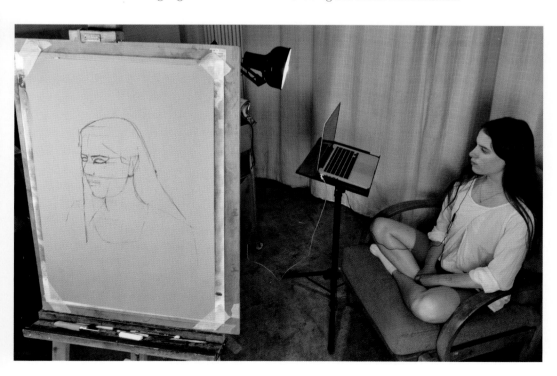

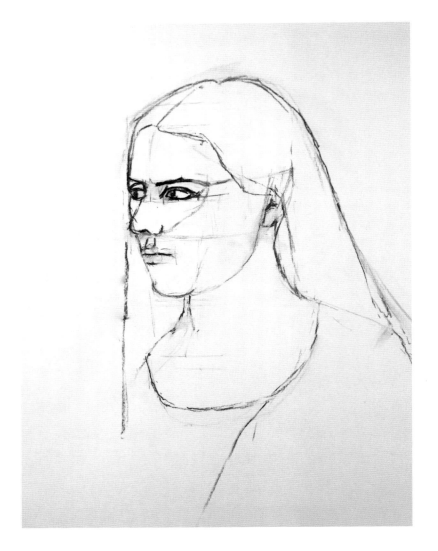

Tip

If you plan to use measuring techniques, you will probably find it easiest to have the model positioned on the same side as your drawing arm so that you can extend it easily to take measurements.

STAGE 1

You may find it useful to do a small, quick sketch before you commit yourself to your main drawing. This sketch doesn't need to be worked up or even to have any likeness to your model, but it will help you place the model's head on the paper in the right place and at the correct scale.

Once you feel confident that you know where the face needs to be on your paper, start marking out the extents of the key facial features with a thin stick of natural charcoal. Take your time doing this and keep checking the angles and distances between points (see pages 22–23). Don't worry about getting a likeness at this stage or of drawing in any detail – just do your best to get all of the key features in the right place relative to one another.

In terms of proportions, the main features on the face conform to some fairly universal rules. Here are a few general points when the face is seen directly from the front or side:

- The eyes are always about halfway between the top of the head and the chin.
- The distance between eyes is about an eye width.
- The tops of the ears align with the eyebrows, while the bottoms align with the bottom of the nose.
- The bottom of the nose is about halfway between the eyebrows and the chin.
- When seen from the side, the ear is just behind the vertical centre line.
- The mouth is about two-thirds of the way up from the chin to the bottom of the nose.

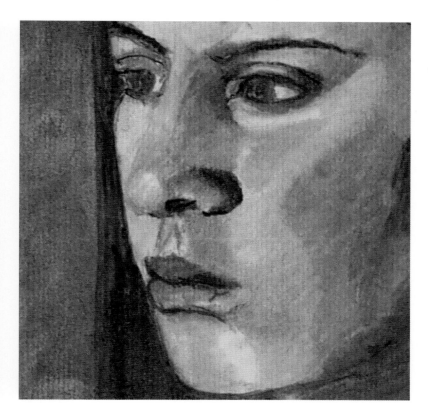

STAGE 2

Working straight over the top of your outline drawing, block in the broad areas of tone without trying to capture detail. Be bold during this phase, and blend as you go to build up the values gradually. Fill in the background and work the charcoal into the paper with a large blending stump or your fingers. Pay close attention to how different elements of the face are on different planes relative to the light source – and are therefore different values.

Once the larger areas are blocked in, start working gently on the smaller areas around the eyes and nose, and graduate your shading where you have rounded forms turning away from the light source. Take some time to be as accurate as you can and keep comparing areas of value – remember to keep asking yourself if the area you are drawing is lighter, darker or about the same as the other areas of the drawing.

By the end of this stage, you should have a drawing that could be considered almost complete. You may even want to compare the aesthetic simplicity of this with the final image I produced. If you feel this is the case, then have the confidence to add any final details and stop – the next two stages merely add some detail and enhance the sense of three dimensions.

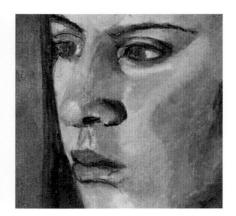

Tip
When drawing the features, keep in mind the octagonal prism in Light and Shadow (see page 17). Notice how various parts of the face are on different planes, which are at different angles to the light source so the tonal value varies accordingly. The side of the nose, for example, is on about the same plane as the side of the cheek, so the tonal value is similar.

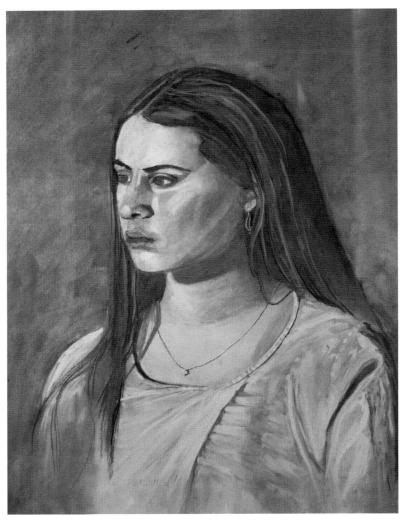

When drawing the creases on the white shirt, only the slightest amount of value is needed to imply the folds. For both the shadows and the highlights (see opposite page), the white or dark medium is dragged lightly across the surface of the paper in a gestural manner. If you feel it needs blending slightly, try doing so very lightly with your finger across the surface of the paper – don't rub it in.

STAGE 3

In this stage, you can start working in some of the detail using subtractive drawing with erasers, cloths and blending stumps. Try to have a few erasers of different sizes and shapes to hand and do as much as possible with the larger ones before attempting the fine detail. As with the previous stage, try to focus on identifying the main blocks of tonal variation before tackling the detail.

As you begin the final stages of tightening up and adding detail you can alternate between additive and subtractive drawing, but try to avoid the temptation to overwork the drawing. It can be much more visually interesting if you can create the illusion of something using a loose gesture.

Add the hair in layers, starting first with the rear layers and working forwards while looking carefully to determine whether each layer is lighter, darker or about the same as the layer you are drawing over. Alternate between additive and subtractive drawing to get the correct values and to add fine detail.

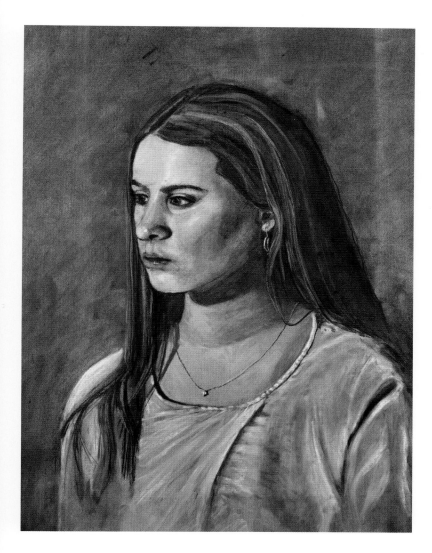

STAGE 4

In this drawing, you do not have the option of revealing the white of the paper to achieve your highlights, so the final stage is to use a white medium (often marketed as 'white charcoal') for the highlights. The key is to be exceedingly sparing with the use of white. If you are using white charcoal in pencil form, it will be worth making the effort to sharpen or trim it using a craft knife to reveal a ½in (1cm) or so of the white 'lead'.

When drawing, hold the pencil at the end to ensure that you apply little pressure and draw on the side of the pencil lead rather than the pointed end, so that the medium is deposited sparingly on the very surface of the paper. Remember that you can always apply more to go lighter still, but white charcoal is more difficult to erase once it is on the paper. For the broader areas of white, such as on the blouse, you may prefer to use white charcoal in block form to loosely emphasize the roll of the material and the creases.

Once applied, blend the white charcoal in using a clean blending stump, soft cloth or your finger, with the exception of the extreme highlights. These go on as the final touch, such as the stone on the necklace, the earrings and the points of highlight on the nose and lips.

Use a sharpened white charcoal pencil to add highlights on the earrings.

FOCUS ON

Advanced Techniques

After using charcoal on several drawings, it's time to experiment with some more advanced techniques. Every now and then you might be after a particular effect that is difficult to achieve through conventional charcoal drawing methods, so here are a few ideas that might help.

ABOVE *The colour reveal technique enables orange watercolour to subtly show through the charcoal layer on top in this picture of a robin.*

Masking

This is a technique used to temporarily cover a portion of your drawing surface so that you can avoid getting any charcoal on that part of the image while you work around it. You use masking to produce a sharp-edged transition from one value to another and, once masked, you can either add or subtract charcoal to lighten or darken the surrounding area – or to maintain the white of your paper. You can buy specialist masking tapes and masking fluids or you can simply lay a piece of card or paper over the top of an area and hold it firmly in place while you work.

MASKING TAPE

Tape is useful for masking straight lines such as when you might want to maintain a sharp white border around a drawing. To avoid tearing the paper you will need to use a low-tack tape or to reduce its tackiness by repeatedly pressing the tape down on a hard surface and lifting it off again.

MASKING FLUID

For curved or free-form areas, you can apply masking fluid with a paintbrush. Wait for it to dry completely before adding your charcoal. You will find it difficult to remove without wiping charcoal particles onto the paper as you rub it off. Fixing the charcoal first can help (see pages 66–67), but a better way is to lift the edge of the dried masking fluid with a sharp blade and then pull it off using a pair of tweezers.

Other advanced techniques

You can produce a range of effects, some of which involve combining charcoal with other mediums, while others involve unusual techniques. Most of these have been derived from creative thinking and experimentation, so I encourage you to experiment yourself. Not only is it fun, but you may also come up with something new and exciting.

Lightening a horizon line (left) by laying a piece of card over a drawing and wiping along the edge with a clean cloth to remove charcoal.

When using a pair of tweezers to pull off dried masking fluid from a complex shape, such as this star (right), work carefully around the edges towards the centre.

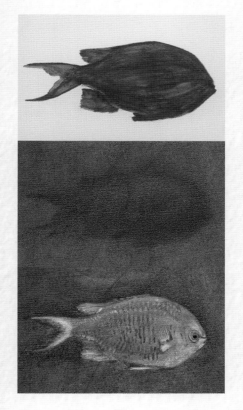

In colour reveal, the original colour (top) will not appear the same once the charcoal is applied (centre) and rubbed away through subtractive drawing (bottom).

COLOUR REVEAL

You can add some colour to your charcoal drawing by combining it with watercolour paint. In colour reveal, for example, lay down a layer of watercolour paint in an even tone and let it dry completely before laying charcoal over the top of it. Now that the paper is prepared, use subtractive drawing to reveal the colour underneath. The beauty of this method is that the tone of the watercolour is regulated by the value of the charcoal. You can remove just some of the charcoal for a soft, subtle effect as in the robin (opposite page), or by erasing hard you can also remove some of the coloured pigment to allow light to reflect off the white paper, lending a sense of luminosity to the drawing, as in the blue fish (see left).

INDENTATION

Pressing hard into the drawing paper with a sharp object produces very fine grooves that are virtually invisible to the eye. However, when you draw over them with charcoal, they reveal themselves as white lines. An effective method is to lay a piece of thin paper over the top and draw with a ballpoint pen, pressing very hard. Remember, however, that there is no reversing this process if you don't like the results.

ACETONE

When acetone (sold as nail varnish or nail polish remover) is dripped onto charcoal, it leaves small circular marks before evaporating quickly. Consider how you could use this effect in your own charcoal drawings and how you could apply it with different tools, such as flicking it with an old toothbrush.

REVERSE DETAILS

Another way to use masking tape is to create fine details in a drawing. Remove the tackiness completely before laying it gently on top of the area where you want to reveal the surface underneath. Once in place, use a pencil or pen to draw onto the tape, pressing down hard. Lifting the tape away will also lift off the charcoal underneath to reveal the fine detail.

These circles were created by a pen using the indentation technique. They appear in reverse in the charcoal on the drawing paper.

Acetone dripped onto drawing paper covered in charcoal will form circles within the charcoal.

Lifting masking tape off the work with a design drawn on top reveals charcoal sticking to the tape and the reverse design left on the work.

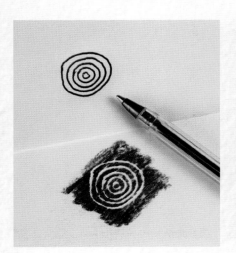

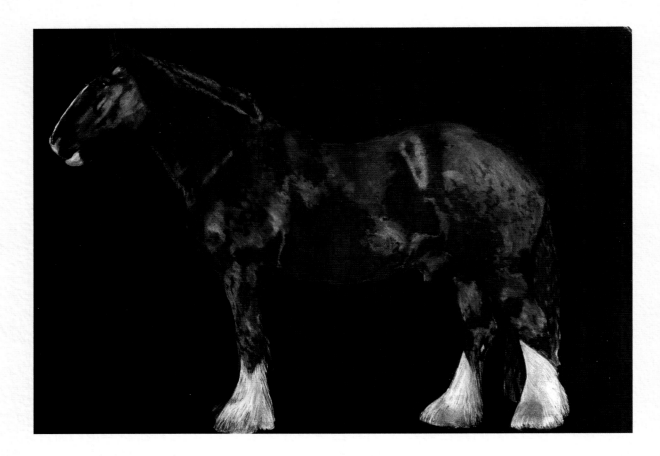

Shire Horse

*In this final tutorial, you will find I have scaled things up
with a suitable subject matter for the ultimate of challenges –
black against black.*

YOU WILL NEED

a large sheet of good-quality heavyweight cartridge paper
• several medium-thick natural charcoal sticks • a couple of compressed charcoal pencils
• a couple of compressed charcoal blocks • blending stumps • a ruler • a soft cloth

Trelawney is a shire horse owned by a school on the edge of Dartmoor National Park near my home in England. He is a massive 17 hands tall (about 5ft 6in/173cm), but he is so well socialized and gentle that he is a favourite with everyone he meets. I loved the sheen of his black coat and thought it would be interesting to place an image of him against a black background so that only the slight variations in value and texture indicate his form. Although it is not a true chiaroscuro charcoal drawing, where there is a strong contrast in light and shade, it does borrow from the idea of allowing the edges of a form to merge into the background.

Scaling up with a grid

Trelawney is a very large horse, so I felt he deserved a large piece of paper. The largest standard size available in my local art shop is about 39 x 27in (100 x 70cm), but the principle of scaling up is exactly the same if you want to go even larger. In terms of composition, I placed the horse almost in the centre and left little border around him. This gives the visual suggestion that he is such a large horse he has to fill the whole frame of the image.

The photograph was taken on an overcast day, and I got one of the students to hold him steady while I took it. I removed the background on a computer to better illustrate the process, but this is not necessary and it doesn't matter if your photo has a background. The image was printed out on standard letter size (or A4) paper on my home printer, and then I drew a grid of squares on it using a fine line pen. I drew exactly the same number of squares on my drawing paper in the same format – in this case ten wide by seven tall, but it could be applied to any shape piece of paper. The grid on the drawing paper was drawn using natural charcoal so that the lines could be erased where necessary as the drawing proceeded.

Use a ruler to measure and divide the lines equally across the photograph, or other reference material, and then create an equal number of squares on your drawing paper.

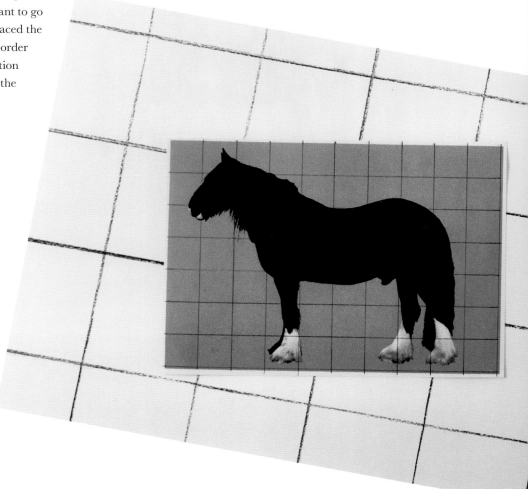

Tip
When you place such a large drawing on your easel, make sure you adjust it to a comfortable working height. You need to be able to reach the top part of the drawing as well as the bottom with the minimum of straining.

STAGE 1

Begin by marking out the outline of the
horse with a narrow piece of charcoal.
At this stage, don't worry about accidentally
smudging and smearing the charcoal lines.
Count along the squares on your paper
until you find the same location on your
reference image. Now look carefully at the
source photo and observe where the outline
intersects each square. Sketch in the lines.
If you don't think it's right, just wipe away
what you've drawn with a soft cloth and
start again.

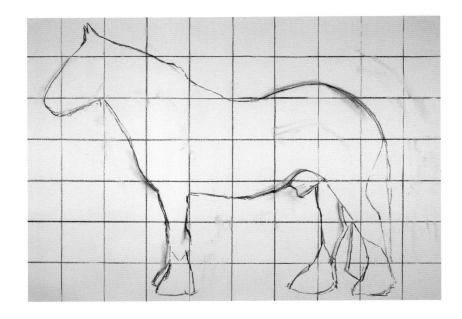

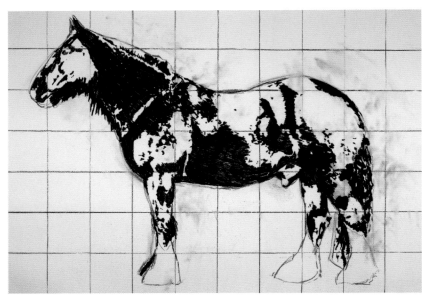

*Notice that the drawing is loose and
rapid while aligned with the form of
the body – in this case, running in the
direction of the neck.*

STAGE 2

Because you will be drawing the image in layers, it will look flat initially, but the
form will be revealed as you work through the drawing. Leave the black background
until last so that you don't accidentally smudge and smear it. Use a good-quality dark
compressed charcoal pencil or stick that adheres well to paper to draw in only the
darkest darks in the horse, making sure you refer to the grid to place the marks in
the correct place. You can use a rapid drawing action to get the marks on the paper,
because at the moment you don't need to be precise. Don't worry if the white crevices
of the paper texture show through – you will work the compressed charcoal into the
paper later on. Remember that the human eye can pick up very slight detail, so draw
your lines along the contours of the body. These marks will be almost imperceptible,
but they will help to create the illusion of volume.

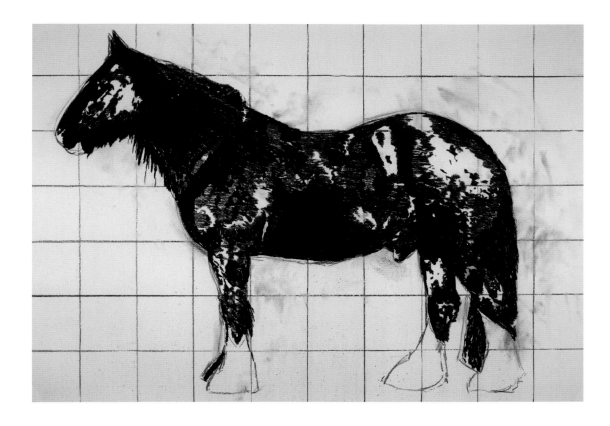

STAGE 3

Now use some natural charcoal to draw in where you judge the next layer of tonal value to be. You can draw right over the top of the compressed charcoal layer, because this will help to work it into the paper and add an additional layer of charcoal particle that will help to produce nice dark tones. Again, remember to work along the contours of the form of the horse, such as around the hindquarters and belly, to help give it a three-dimensional shape.

Use a medium thickness of natural charcoal for this stage, because you want something thick enough to take some firm pressure as you work the charcoal into the paper yet something narrow enough to attain a reasonable amount of detail. Try to really work the charcoal into the weave of the paper as you draw so that it doesn't get wiped away when you start working over this layer with blending stumps in the next stage.

Tip

You don't need to fill in the areas with a solid mass of medium. It is fine for the lighter lines to be visible within your shading lines. These will add subtle variations in tonal value.

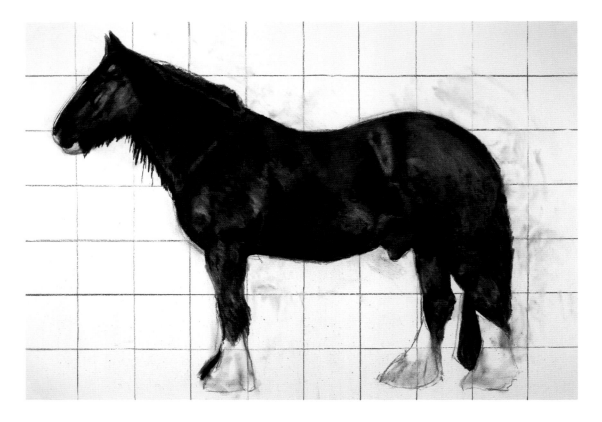

STAGE 4

It may look as if more charcoal has been added in the picture above, but in this stage all we do is blend what we've already put on the paper. Just like in the Sailing Ship tutorial (see pages 60–65), this is where blending makes the image look more real and less flat. Your aim is to turn three layers of tonal value into a wider range of values.

This process will require a leap of faith, because you will have spent a lot of time applying the first two layers. However, be bold – the more effort you put into this step, the more successful the results will be.

Using a blending stump, work vigorously across the compressed charcoal and natural charcoal to soften the edges and carry loose particles across the areas of paper that remain white – with the exception of the areas you want to remain white, which are on the feet and the head.

Just as when you were applying the charcoal, blend along the contours of the body. Use a large blending stump to work in a gestural motion across large areas, and smaller ones to soften the edges of particular areas. If your white areas require a little more charcoal, apply it, but gradually – there should be quite enough charcoal on the paper to carry across onto your lighter areas. You can now see why it was not necessary to be too precise when applying the first two layers.

Tip
You don't need to draw every strand of hair to achieve a realistic impression. Just pick out a few that are either light against a dark background or dark against light and draw them in as finely as you can.

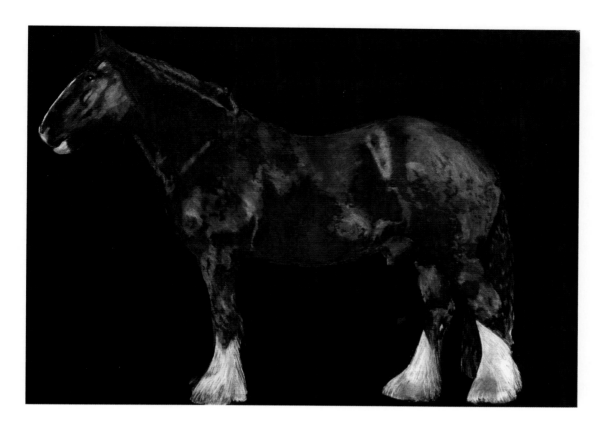

STAGE 5

In the final stage, you will be putting in your dark background and completing the feet and face. Using a broad stick of a really black compressed charcoal, draw around the shape of the horse before filling in the entire background. This process will probably create a lot of dust, so you may want to consider wearing a facemask or doing it outside. As when you worked the other areas of value, it is likely that the white of the paper will show through after your first pass, so you will need to work the compressed charcoal into the paper rigorously with a blending stump or your fingers.

The best way to achieve the white hair around the head and the hooves is with subtractive drawing (see page 19), but you will first need to darken the value of these areas with some blended-in natural charcoal so that you have something to subtract from.

As with the Jackdaw (see pages 68–73), one of the final steps is to sharpen up the eye, using your dark compressed charcoal pencil to get the darks and a pencil eraser for the highlight.

Considering the amount of charcoal used, it is a good idea to protect the final drawing behind glass (see pages 66–67). Doing so will also have the added benefits of adding to the illusion of depth and making your marks less visible.

Tip
Fingers can be effective blending tools, but first wash your hands well with soap to remove undesirable oils in the skin so they won't be worked into the paper. Or wear vinyl gloves to avoid getting your hands black.

Glossary

ATMOSPHERIC PERSPECTIVE The effect of atmosphere on distant objects that makes them appear lighter in value and less defined the further they are away.

BACKGROUND The plane of a drawing that is at the back of a scene, behind the foreground and middle ground.

BLEND To smooth out drawing marks to produce areas of even tonal value or a graduation from dark to light. Also to merge different mediums together.

CARTRIDGE PAPER A high-quality type of heavyweight artist's paper used for illustration and drawing.

CENTRE LINE The lines running vertically and horizontally through the centre of your drawing area.

CHIAROSCURO Images with high contrast between light and dark, often with deep shadows that partially obscure the complete form of objects.

COMPOSITION The arrangement of elements within a scene.

CONTOUR To draw lines in a direction that follows the form of an object, which enhances the appearance of volume.

CONTRAST The difference between light and dark in a drawing; low contrast is when there is little difference and high contrast when the difference is great.

FOREGROUND The foremost plane of elements within an image lying in front of the middle ground.

FORM An object's three-dimensional shape that takes into account its volume, thus its height, width and depth.

FORMAT The shape and orientation of a drawing; landscape, portrait and square are commonly applied to artwork.

GLASSINE PAPER A special paper used to protect artworks; it has a smooth surface that prevents abrasion.

GRAPHITE PENCIL A standard pencil with the 'lead' formed from graphite.

HATCHING A technique for producing shading achieved by drawing multiple parallel lines.

HIGHLIGHTS The areas within an image that are the lightest lights.

HORIZON LINE A notional horizontal plane projecting at the artist's eye level.

LANDSCAPE A drawing depicting outdoor scenery; when applied to formats, it describes a rectangle with its longest length along the horizontal.

LINEAR PERSPECTIVE A method of describing depth within an image.

MATT A surface that is non-reflective.

MEDIUM Any material with which drawing or painting marks are made.

MONOCHROME An image composed in black and white or shades of grey – lacking colour.

MOUNT BOARD A high-quality cardboard product used to create a surround for artwork when framing.

NEGATIVE SPACE The shape of the spaces between objects in a drawing.

PANORAMA An elongated rectangle format longest along its horizontal length.

PERSPECTIVE A set of rules in which objects appear smaller the further away they are; in drawing, straight lines merge as they approach vanishing points, giving a sense of depth in the artwork.

RULE OF THIRDS A system of laying out elements within a drawing according to a grid system intended to aid a composition.

SHADING Adding medium within areas of a drawing to darken tonal values.

SOFTEN To make the boundaries between different elements within a drawing less defined through blending, smudging or smearing.

THUMBNAIL SKETCH A tiny, rapid sketch to assist in compositional decisions.

UNDERDRAWING An initial measured drawing or sketch to plot all of the elements in the correct position before adding tone or texture.

VALUE Also referred to as tonal value, to describe the degree to which an area of shading is light or dark.

VANISHING POINT The notional point on a horizon line at which lines of linear perspective converge to a single point.

About the Author

Richard Rochester studied Fine Art at Exeter College of Art and Design. Following his graduation, he served for 18 years in the British Army and the Royal Marines before returning to Exeter and his love of art. Richard works across a range of creative disciplines but is particularly inspired by charcoal.

Living near the coast and countryside of the South West of England has a strong influence on his art and he is possibly best known for his large-scale and immersive landscapes, as well as his work with the not-for-profit humanitarian endeavour 'Journey Through Conflict'. Beyond the studio Richard regularly delivers talks, demonstrations and workshops to art groups and societies. He is also an instructor with the online training organisation Yodomo.

www.richardrochester.co.uk

Acknowledgements

My thanks to everyone at GMC who helped to bring this book to fruition; in particular to Dominique Page for inviting me to join the project and for her support throughout. Also to Theresa Bebbington for bringing her wealth of experience to the editing process, to Wayne Blades for designing the layout and to Nigel Gifford for taking the portrait photograph.

Closer to home I would like to thank my partner Jen and my daughters Charlotte and Lily for their patience and encouragement, and for providing an invaluable sounding board for my ideas as the book developed.

My final acknowledgement is to my late mother, Barbara Rochester – an accomplished artist and undoubtedly my greatest influence.

Index

A

acetone 87
angles 22
atmospheric perspective 25, 78

B

background 27
blending 12, 18

C

charcoal, types 10–11
Chiaroscuro Night Scene 74–79
colour, converting to monochrome 16
colour reveal 87
comparative measuring 23
composition 26–27
cropping 26

D

depth 27
dragging charcoal 20
drawing boards 13

E

easels 13
equipment 10–13, 19, 21, 59, 63
erasers 12, 19

F

fixatives 12–13, 66–67
focus 27
format 47
framing 67

H

hatching 15
horizontal sighting 22

I

indentation 87
intersections 22

J

Jackdaw 68–73

L

landscape sketches 54–59
laying down an even mid-tone 20
leading lines 27
light 13, 17
lightening 12, 18
line width 14
linear perspective 24–25, 78

M

mahlsticks 13, 63
masking 86
materials 10–13, 19, 47, 81, 86, 87
measuring, comparative 23
mistakes, correcting 36, 45

N

negative space 23

O

observational drawing techniques 21–23

P

paintbrushes 13
paper 11, 19, 47, 81
penumbras 17
perspective 24–25, 78
photographic references 49
planning 46–47
plein-air 55, 59
Portrait 80–85
preserving work 66–67
pressure, applying 14

R

reference materials 46, 49
removing charcoal 18, 19
reverse details 87
rule of thirds 26

S

Sailing Dinghies on a Still Morning 48–53
Sailing Ship 60–65
scaling up 61, 89
Scallop Shell 34–39
securing work 41, 59
shading 14–15
shadows 17, 83
sharpening tools 12, 13
Shire Horse 88–93
sighting 22
simultaneous contrast 16, 17, 77
sketching 21, 29
Still Life with Water Jug and Plants 40–45
stippling 15
storing work 67
subject matter 46
subtractive drawing 19, 36

T

terminators 17
thumbnail sketches 29
tonal values 16

V

values range 16
Vegetables Still Life 28–33
viewfinders 21

To order a book, or to request a catalogue, contact:

GMC Publications Ltd

Castle Place, 166 High Street, Lewes, East Sussex

BN7 1XU, United Kingdom

Tel: +44 (0)1273 488005

www.gmcbooks.com